DARLINGTON
IN
50
BUILDINGS

CHRIS LLOYD

AMBERLEY

About the Author

Chris Lloyd is the chief feature writer of *The Northern Echo* and the *Darlington & Stockton Times*, where his articles about local history, places and people are among the papers' most popular content. A former North-East Journalist of the Year, his interest in local history was sparked around thirty years ago when, as a graduate of the University of St Andrews in Scotland, he was parachuted into Darlington – a town he'd never visited before – as a trainee reporter. He set out to understand why the town existed and who and what had shaped it – this is his eighth book in that unending quest. Married to Petra, with two children, Genevieve and Theodore, he is also known for his talks and broadcasts about local history.

First published 2017

Amberley Publishing, The Hill, Stroud
Gloucestershire GL5 4EP

www.amberley-books.com

British Library Cataloguing in Publication Data.
A catalogue record for this book is available from the British Library.

ISBN 978 1 4456 6682 2 (print)
ISBN 978 1 4456 6683 9 (ebook)

Origination by Amberley Publishing.
Printed in Great Britain.

Contents

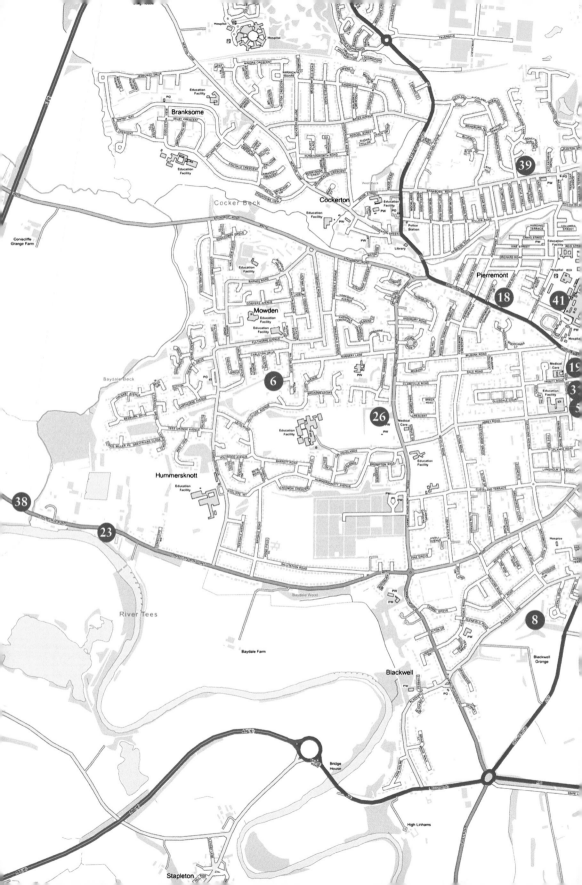

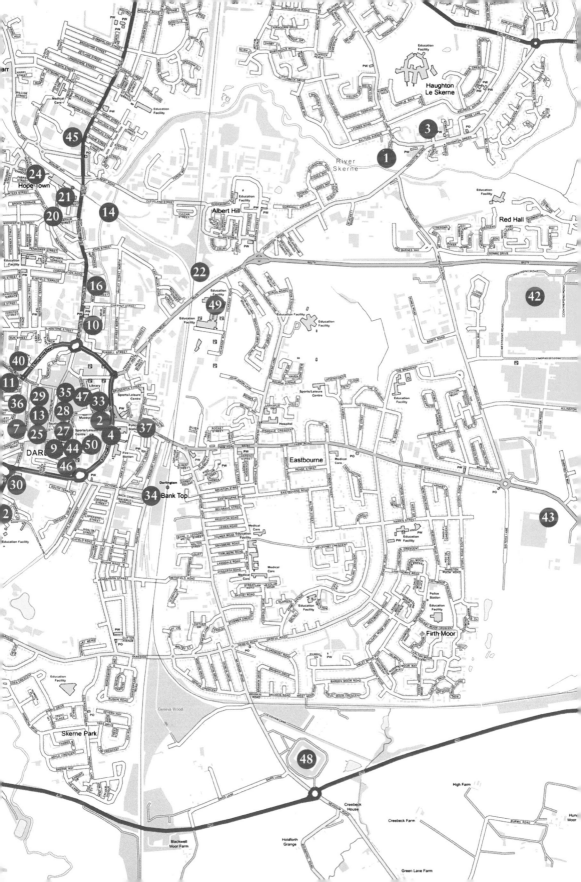

Key

Introduction

Darlington is Deortha's town on the banks of the shining River Skerne, although really it was Bishop Hugh de Puiset, the great builder bishop, who plucked it out in the late twelfth century by building a huge church, St Cuthbert's, 'the Lady of the North', and a palace on its riverbanks.

The bishop's patronage allowed Darlington to become the marketplace – and so the agricultural capital – of its district.

However, practically all of those medieval stories were lost on 7 May 1585, when a great fire swept through the streets, consuming all the timber houses and all the possessions of those wealthy enough to have stone dwellings – only St Cuthbert's survived. The fire rendered three-quarters of the town's 1,200 population homeless, but over the following decades they rebuilt on the old layout, with High Row being the principal street looking down over the marketplace.

The new generations discovered that the waters of the Skerne possessed remarkable bleaching properties, and so the second age of Darlington is founded on the woollen industry, which led into linen, so that by the mid-seventeenth century the town was the largest – and finest – producer of huckaback (a coarse cloth used for bedspreads and tablecloths) in all of Europe.

Darlingtonians then found that the Skerne's waters also possessed enough oomph to power mills, and the Backhouse and the Pease families had the wherewithal to turn the cottage piece-working practices into larger scale factory-based industries, complete with their own financial institutions that lubricated the wheels of those industries. Those Quaker families were also far-sighted enough to embrace new technologies – such as steam power – in their mills, which, by the start of the nineteenth century, left them with enough spare capital to invest in another futuristic venture: a railway, operated by newfangled locomotives, to connect their south Durham coal mines with their port near the mouth of the River Tees.

The Stockton & Darlington Railway opened on 27 September 1825, and ushered in the third age of Darlington. It was an age of great prosperity, certainly among the industrialists. Many of the municipal, industrial, religious and domestic buildings featured in this book date from this period. The most distinctive of them were designed by two architects in particular. Alfred Waterhouse, at the beginning of his illustrious career, created the iconic market complex as well as Backhouses Bank opposite, while his protégé, G. G. Hoskins, was responsible for everything from the library to the King's Head. While Waterhouse went on to gain national recognition, Hoskins stayed in town, creating a grandiose Gothic style in two-tone terracotta, which was so wonderfully overblown that it gained for Darlington the nickname of 'the Athens of the North'.

Darlington's attempts to enter the modern architectural age in the 1960s and cover the town centre with dreadful concrete-and-glass boxes were stymied by planning

inspectors and the prospect of public revolt, so the town has retained an interesting array of architecture where the space-age Town Hall and twenty-first-century office blocks sit alongside the Waterhousian wonder of the town's defining clock tower, while de Puiset's magnificent lady looks on.

The fifty buildings here are all within the main roads that ring the town of Darlington – the A66 and the A1(M) – and all still stand, so it is possible to go and look at them. Research on them, as ever, began in the Centre for Local Studies in the Edward Pease Free Library, where the staff are always most helpful, and was augmented by the millions of readers of 'Memories' in *The Northern Echo*, who always add their knowledge.

The 50 Buildings

1. St Andrew's Church, Haughton-le-Skerne

The Anglican church beside the Skerne in Haughton is the oldest building in Darlington; the year 1125 is the most commonly given date for the start of its construction, whereas St Cuthbert's in the town centre was only started in the 1180s. Both churches, though, are likely to be on the sites of Saxon places of worship.

St Andrew's oldest parts are its nave and chancel. Its tower – 'broad and massive, rude and plain, yet picturesque' – has early beginnings, although it took at least a century to rise to its full height. There appears to have been a major restoration in the fifteenth century. In the late eighteenth century the transepts, vestry and south porch were added, and then from 1891–95 there was another very extensive overhaul. Among the most significant survivors from all of these revisions are the church's woodwork – the font cover, pews, pulpit, lectern – which are probably from Bishop John Cosin's time, after the restoration of 1660.

The most intriguing of the memorials may be that in the floor of the chancel to Revd Thomas le Mesurier, who died in 1822, two years after he had been convicted of flying out of the church in his long black robes and punching fourteen-year-old Robert Richardson in the mouth so hard that he dislodged a tooth. Le Mesurier, well known for his Tory views, had been chaplain to Home Secretary Lord Sidmouth, who, in 1819, was blamed for the Peterloo Massacre in Manchester, where at least fifteen working-class protesters had been killed by a cavalry charge. The vicar assaulted the teenager during the 1820 election campaign when a parade provocatively marched past the church shouting radical slogans. For his sins, the rector was fined £10.

St Andrew's Church, Haughton, with the schools to the left, in around 1815.

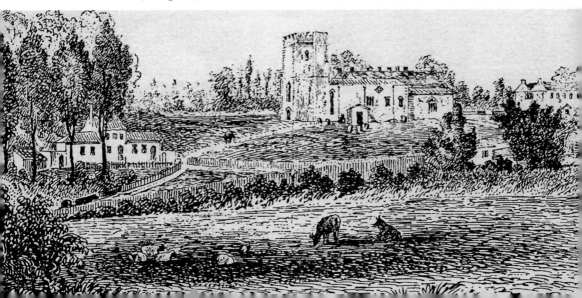

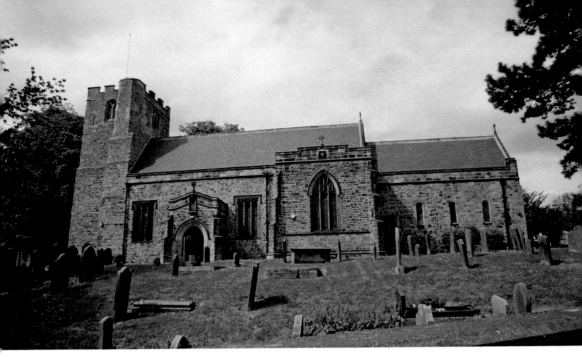

Parts of St Andrew's Church in Haughton are around sixty years older than the oldest corners of St Cuthbert's Church.

2. St Cuthbert's Church

There has been a church beside the River Skerne since time immemorial – everything points to there being a simple Anglo-Saxon building there, of either wood or stone, and everything points to it being destroyed, either by Viking or Norman invaders. Tradition suggests that churches dedicated to St Cuthbert sprung up where the venerated saint's remains stopped on their peregrinations in 893 or 995, but there is no record of Darlington having been so blessed.

In the 1180s, Hugh de Puiset, the great builder bishop of Durham, decided to create 'the Lady of the North', perhaps to fit with the palace he was building beside it. His first architect, Richard 'Ingeniator', drew up the plans before his death in 1183, after which William took over. However, there was a break in the work – perhaps in 1195 when Hugh himself died – when the walls were around 8 feet high, although the chancel, crossing, transepts and nave were complete by 1250.

Stone came from the 'purple' bed at Houghton Bank, 6 miles to the west, and Cockfield Fell, 12 miles in the same direction, all of it travelling in on packhorse. Red sandstone came from the Tees riverbed at Croft.

In the fourteenth century, wealthy prebend Henry de Ingleby, who died in 1375, raised the tower and a little later the spire was placed upon it, thus creating a landmark visible from Roseberry Topping; however, it also caused a major problem: the crude foundations could not bear the additional 150 tons of weight. From 1375–1408 there were desperate attempts to shore the tower up, culminating with the erection of the rood loft.

With calamity averted, Thomas Langley, bishop between 1406 and 1437, presented eighteen misericords – hinged seats upon which a clergyman may discreetly rest. Eleven survive, and their eccentric carvings are among the church's greatest curios.

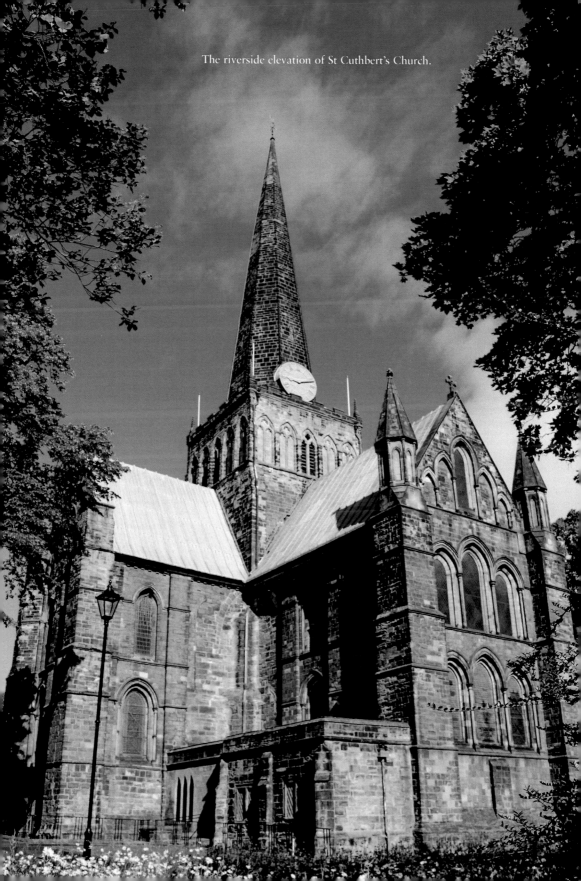

The riverside elevation of St Cuthbert's Church.

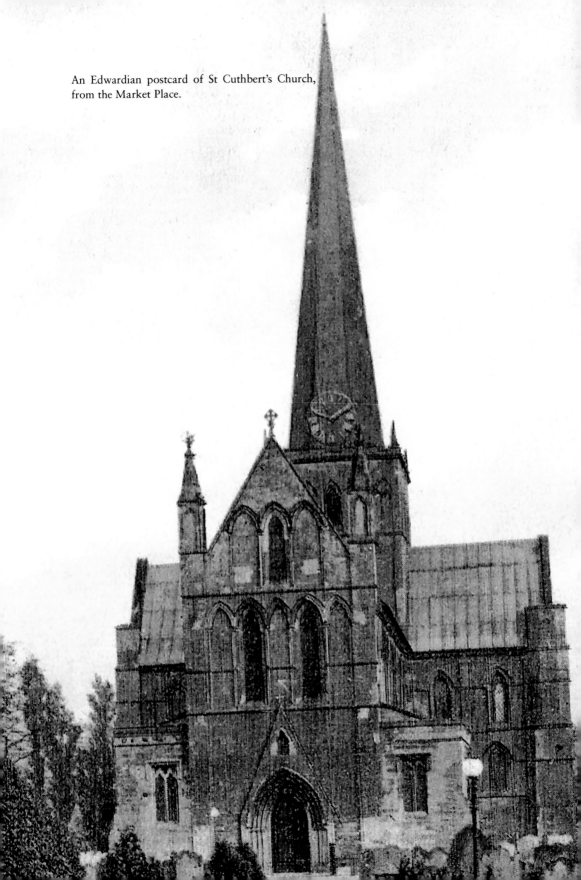

An Edwardian postcard of St Cuthbert's Church, from the Market Place.

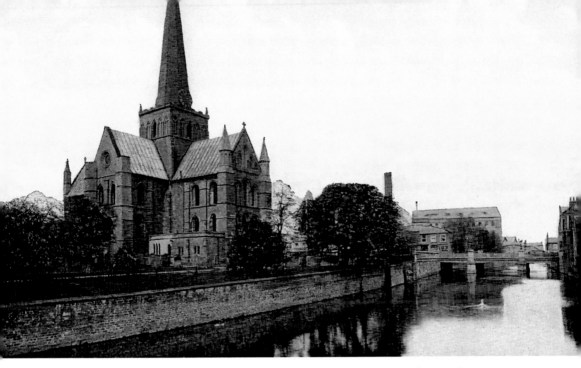

St Cuthbert's Church and Stonebridge – known to some as St Cuthbert's Bridge – with Peases Mill in the background of this Edwardian postcard.

W. Hylton L. del. O. Jewitt. sc.

The most curious of the early fifteenth-century misericords shows an old man, naked other than his boots, having a snooze in St Cuthbert's Church.

On 17 July 1750, lightning destroyed the top 50 feet of the spire. It was badly rebuilt, and the weathercock ended up 8 feet lower than it had been – but it is still a dizzying 150 feet higher than the river.

By 1862, pews hanging from the interior walls and the public desire to be buried in and around the church were threatening the structure's stability, so Sir George Gilbert Scott, the renowned church architect, was called in. Working with local architect J. P. Pritchett, he swept away much that was medieval, but when he finished in 1865 the structure was no longer in danger of imminent collapse.

3. Butler House, Haughton

Opposite St Andrew's Church, the oldest building in Darlington, is the town's oldest domestic building, which was the home of the rector of Haughton-le-Skerne – perhaps right back to Rector Reginald in 1131, the earliest known incumbent.

The rambling rectory has an eighteenth-century front, known as Butler House, but behind sprawls a much older collection of wings, outhouses and stables. One part is at least fifteenth century and has a core that is believed to be twelfth century.

Due to an ecclesiastical accident, the rector of Haughton was one of the wealthiest clerics in the Durham diocese, earning twice as much in Victorian times as the three vicars next door in Darlington combined, while tending to a flock a fifteenth of the size. Consequently, successive unscrupulous bishops of Durham appointed their family and friends to the living, including William Talbot who, in 1722, appointed his favourite Oxford University student, Joseph Butler, to the lucrative living. However, when Mr Butler arrived, he was so shocked by the state of the tumbledown rectory that he persuaded the bishop to transfer him to Stanhope, where the wages were equally good and the roof watertight.

Mr Butler's theological thinking in Weardale was so admired that Queen Caroline, the wife of George II, appointed him as her Clerk of the Closet – her head cleric – and every evening between 7 p.m. and 9 p.m. he attended her majesty. Caroline died in 1737, but spoke so highly of Mr Butler on her deathbed that he was made Bishop of Bristol and then, in 1750, Bishop of Durham.

He spent much money on his residences of Auckland Castle and Durham Castle, but because he remembered the 'dilapidations' of Haughton rectory, he paid for a new wing – Butler House – to be built. Over time, the other wings of the rectory were pared off for non-church uses, and since 2011 all of Darlington's oldest domestic building has been privately let to someone other than the rector.

Butler House, Haughton, by George Algernon Fothergill in 1904.

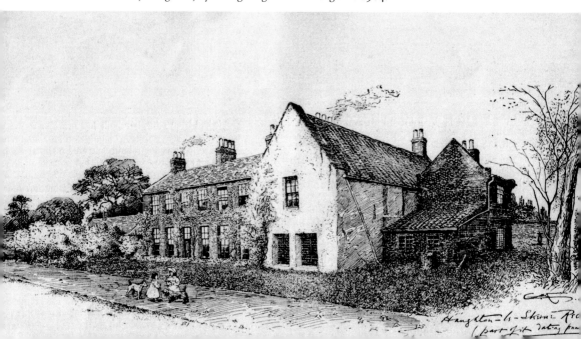

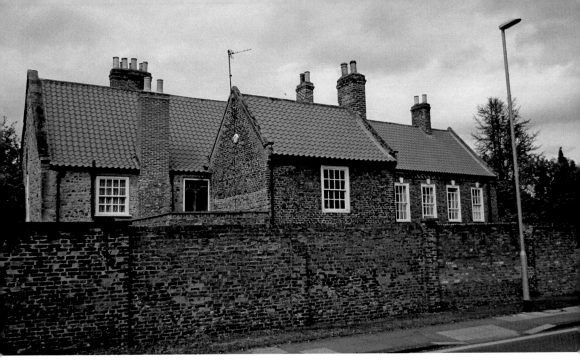

Butler House, the oldest residential building in Darlington, is tucked away behind a high wall.

4. Stonebridge

To some, it is Darlington Bridge; to others, it is St Cuthbert's Bridge, but to modern mapmakers, it is Stonebridge – even though now it is made of metal.

The first mention of a bridge here is on 2 December 1299, when Edward I was passing through and gave the town bailiff, Adam de Sutton, 45s 2d 'for the repair of a bridge in his town where the king's treasure and various carriages had to pass'. Adam effected the repairs using nails and planks, which suggests the bridge was wooden – but was it over the Skerne or the Cocker Beck?

The first concrete mention of a bridge over the Skerne is in Cecilia Underwood's will of 1343. She left 13s 4d for the 'ponti ultra aquam de Skyrryn'.

In 1615, Durham magistrates complained that the bridge was 'very ruinous and in need of repairs for wheeled traffic'. They also said that in wet seasons it wasn't wide enough for dry passage, and so a causeway was built over the boggy meanders on the eastern floodplain. This bridge-cum-causeway evolved into the nine-arched wonder that Daniel Defoe passed over in 1727, saying it was 'a high stone bridge over little or no water'.

As the textile industry culverted the river into narrow rushes to drive the millwheels, so in 1767, R. and W. Nelson of Melsonby were paid £860 (£1.3 million in today's values) to build a three-arch bridge of Gatherley Moor stone.

When Bank Top station opened in 1841, this bridge couldn't handle the increased traffic because it had been 'shamefully encroached upon by ugly sheds, etc. built upon the parapet walls', so in 1849, a two-arch, shed-less bridge was built. This was the last of the stone bridges because in 1895, when Peases Mill had changed the nature of the Skerne once more, Teasdale Brothers of the Bank Top Ironworks replaced it. Their bridge embraced the era of the motor vehicle, although in 2015 it was 'severely corroded' and required £900,000 of emergency repairs.

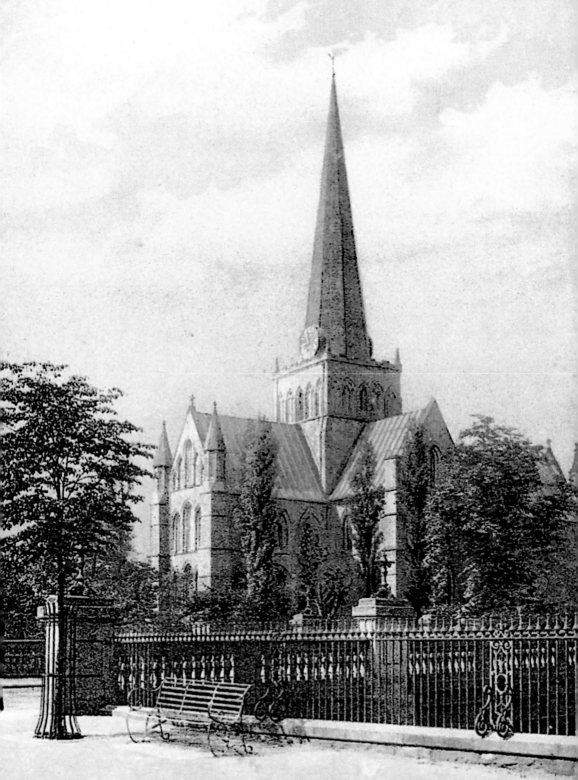

An Edwardian postcard of Stonebridge – or St Cuthbert's Bridge – with the church behind.

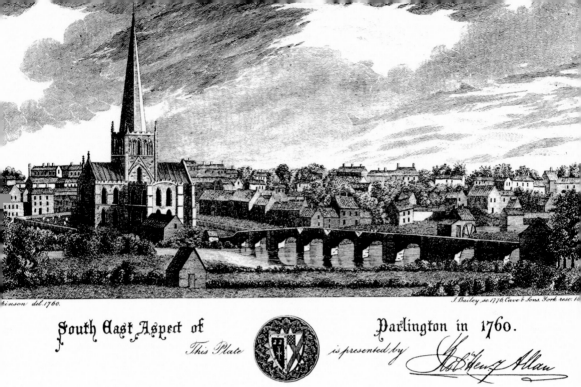

South East Aspect of

This Plate

Darlington in 1760.

is presented by

Rot Henry Allan

inson del. 1760.

J. Bailey sc. 1776. Cave & Sons York rose: 18

Above: The nine-arched Stonebridge over the River Skerne, looking from the east towards St Cuthbert's Church in 1760.

Below: After its restoration in 2016, the name of Stonebridge's makers, Teasdale Brothers, and the date of 1895 are again clearly visible.

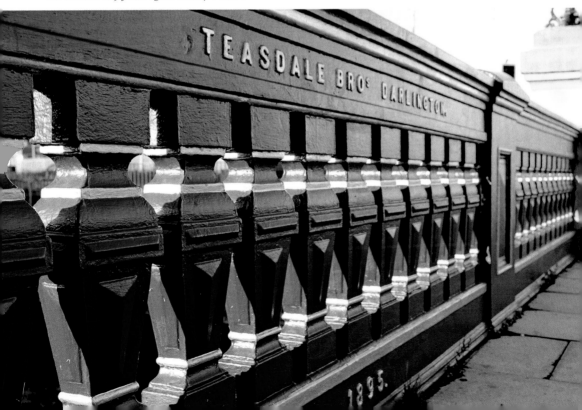

In 1854, historian William Longstaffe wrote: 'Dear reader, did you ever see the soldier on Darnton Bridge who, when you approached, gave a jump on the wall and dashed headlong to the waters below with a gurgle and splash? If you have not, others have. That is all.'

5. Queen Elizabeth Sixth Form College

After the Anglican church, the college has the longest continuous traceable history in Darlington. It began as a grammar school (first mentioned in 1291) and was probably located in St Cuthbert's, with the vicar or curate doubling as schoolmaster, which entitled him to two wages.

Because of the church connection, the school's wealth attracted the attention of Henry VIII's men during the Reformation. When Elizabeth I succeeded Henry, townspeople asked her to refound the school. She granted a charter on 15 June 1563, allowing a grammar school 'to be erected and for ever established for the perpetual education, erudition and instruction of boys'.

This school was based in a little thatched building in the south-east corner of the churchyard, by the river. However, usually because of the absence of the vicar, it was rarely successful: in 1748, it had to be re-refounded as it 'had been greatly obstructed and neglected and frequent contentions and unhappy divisions have arisen', and in 1840, Revd George Wray was removed as head for dereliction of duty.

In 1813, a new school was built beyond the churchyard in the lead yard by architect Ignatius Bonomi. It too failed, but the 1869 Endowed Schools Act allowed a 'new scheme' to be adopted for running the school – a re-re-refoundation at a new location. Land on Vane Terrace was bought from the Duke of Cleveland for £700; public subscription raised £11,300 and the Peases threw in £6,000 and a large clock.

An Edwardian postcard of what was then the grammar school, viewed across Stanhope Park.

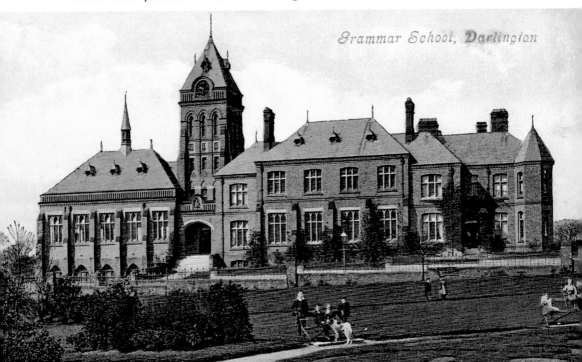

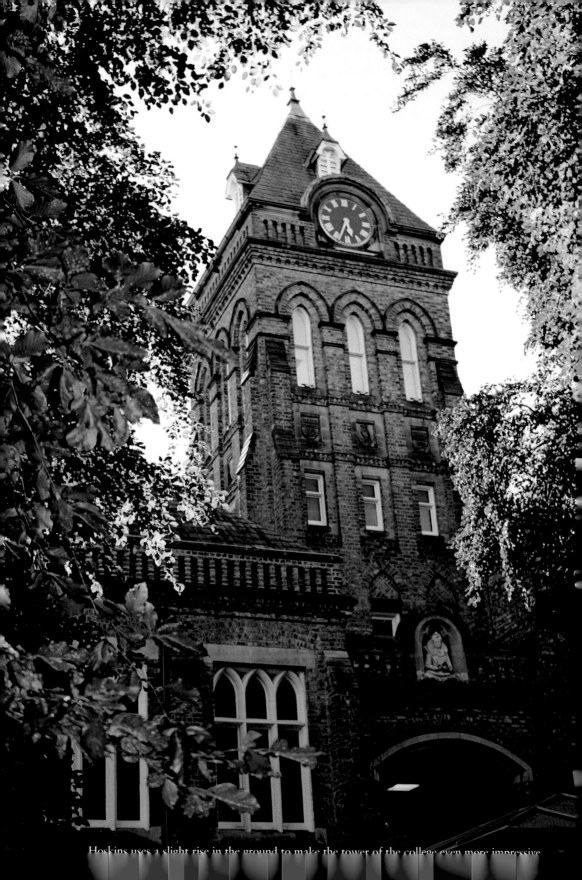

Hoskins uses a slight rise in the ground to make the tower of the college even more impressive.

A 1920s photographic postcard showing the then Queen Elizabeth Grammar School across Stanhope Park.

The new school, designed by G. G. Hoskins, opened on Monday 21 January 1878, with room for 220 boys and twenty-three boarders under Philip Wood, a dynamic and scientifically minded headmaster. It attracted pupils from private academies, started preparing boys for university, and covered its site with extensions so that by 1938 it had 630 pupils, 75 per cent of whom received a free education.

In 1963, the Peter Plan mapped out Darlington's transition to the co-educational comprehensive era. In the autumn of 1970 six secondary schools opened, with the grammar school becoming their sixth form.

The college survived a £1-million arson attack on 16 December 1987. It now appears among the top forty of its kind in the country, with nearly 2,000 pupils.

6. Hill Close House

Hemmed in by the housing estates of Hummersknott and Mowden, Hill Close House is hard to find amid a maze of back lanes, tall walls and taller trees. Yet it is the oldest secular building in the town and it was strategically located on the highest rise in the town – 200 feet above sea level and once named Bushel Hill – with a spectacular outlook towards Teesdale. 'A glorious view of the west imparts to the mind's eye the impressions produced by the charming peeps in some Yorkshire dales,' wrote William Longstaff in 1854.

Hill Close was the farmhouse home of the Emerson family for centuries, until George Allan of Blackwell Grange bought it in 1725, when it was described as 'an elegant stone Tudor house which overlooks a parkland of beautiful scenery'. In 1833, it was the centre of a farm of 150 acres with seventeen fields stretching from Staindrop Road to Coniscliffe Road, and Longstaff described it as 'the only Tudor house of stone in the parish'.

Hill Close House seen from the Hummersknott allotments, which used to be part of its parkland.

He enthused about its 'enormous thickness of wall, deep-splayed mullioned windows and picturesque gables' and, although it was only half the size of its pomp, he remembered how 'one of the room floors was paved with blue flints'.

As it faded further in Victorian times, much of its land became incorporated into the estates of the rising Pease family, who assimilated its ancient walled garden and orchard as their own. In the twentieth century, as the Peases passed and housing estates were built across their parkland, Hill Close was restored from dereliction and, from its slightly elevated position, it still overlooks the sturdily walled garden, which has been used as allotments since 1917.

7. Friends Meeting House

In the nineteenth century, Darlington was known as 'the Quaker town', and the town's football club is still known as 'the Quakers'. The Quaker movement grew out of the English Civil War in the middle of the seventeenth century, and Darlington's first Quakers met at the isolated home of the Fisher family in Honeypot House, Longfield Lane, to avoid persecution. When they died, they were buried in one another's back gardens rather than in consecrated ground until their first graveyard was established behind the Black Bull Inn (known most recently as the Hoskins) on the corner of Blackwellgate and Grange Road. William Penn (1644–1718) is reputed to have spoken there.

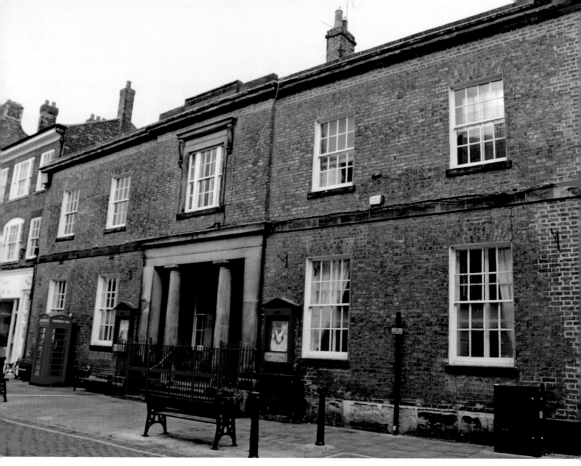

The Friends have been meeting on Skinnergate since 1678.

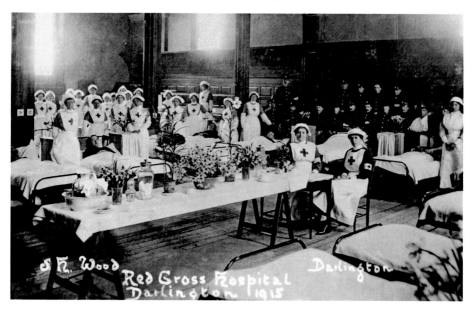

J. R. Wood Red Cross Hospital Darlington 1915

The Friends Meeting House was used as a Voluntary Aid Detachment hospital for recuperating soldiers in the first years of the First World War.

In 1678, the Quakers bought a couple of cottages with land in Skinnergate for £35, and gradually turned them into their meeting houses (one male, one female) with their burial ground behind. In 1839, local Quaker architect and builder Joshua Sparkes began creating the frontage that survives to this day – a simple, neoclassical frontage that reflects the plainness of Quaker habits. Its only adornments are its Tuscan porch and the inscribed stone on the roofline that says 'Friends Meeting House' in capitals.

The heyday of the Quakers was around 1870, when there were around 400 of them in Darlington. Since then, theirs is a history of trying to meet changing circumstances. In 1960, for instance, with their numbers halving, they reduced the size of the meeting room to create other facilities that could be let. In 2009, when regular worshippers were down to a couple of handfuls, the house was put on the market.

Nothing came of it, and today the premises is more open than it has ever been. And, through the archway, the Quaker graveyard is a genuine oasis of stillness amid the town centre hubbub. It contains higgledy-piggledy rows of simple, rounded headstones – all men equal before God – and here in this Skinnergate backwater you can find the families – Pease and Backhouse but also I'Anson, Kitching, Robson, Dixon and Chapman – who were instrumental in making Darlington what it is.

5. Blackwell Grange

In around 1690, George Allan (1663–1744) bought at 'handsome mansion house' at Blackwell and set about creating Darlington's foremost – and oldest – mansion, complete with its own parkland pleasure ground. George, originally from Yarm, had made money selling Hartlepool salt to the government, and he'd had some inside information that enabled him to sell shares in the South Sea Co. shortly before the bubble burst in 1720.

The initial Grange was probably based on the old farmhouse, but was just five bays wide and three storeys high – the entrance to today's hotel.

A mid-Victorian view of Blackwell Grange from Grange Road.

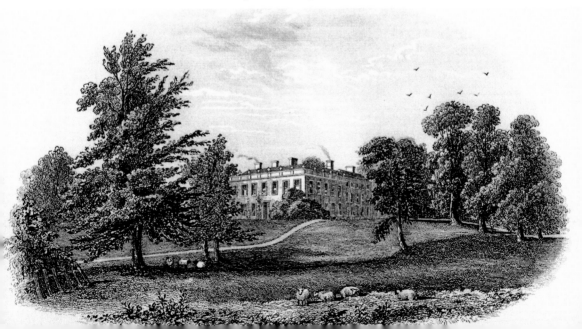

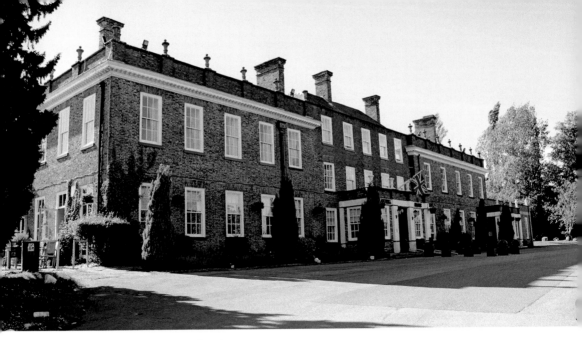

Blackwell Grange is now a hotel.

In 1717, his son, George (1694–1753) married Thomasine Prescott, an heiress to a Blackwell estate who was said to possess 'acres of charms'. While the happy couple were away on honeymoon, George Snr added a south wing to the Grange with the newlyweds' initials on the lead rainwater heads: 'TG1722A'.

It is said that Prince William, the Duke of Cumberland, stayed at the Grange on his way to meet the Scots at the Battle of Culloden in 1746. In victory, he called in on his return and presented George Jr with a painting of a 'Tartan Lady' plundered from the battlefield. However, the Tartan Lady's ancestors had been killed at Culloden, and on the anniversary of the battle – each 16 April– it's said she walks the Grange's corridors seeking an Englishman for revenge...

The Grange passed down the family line to another George (1736–1800) who turned his 'collection of curiosities', which included items Captain James Cook had brought back from Tahiti, into Darlington's first museum in two large rooms. In the mid-nineteenth century, it passed to the Allan cousins, the Havelocks of Sunderland, particularly Sir Henry Havelock (1830–97), who had won the Victoria Cross during the Indian Mutiny of 1857. To complete his inheritance, Sir Henry double-barrelled the surnames to form Havelock-Allan and, after he was killed fighting up the Khyber Pass, the Grange passed to his son, Sir Henry (1872–1953). On his death, after nine generations of Georges and Sir Henrys, the Grange was sold to Darlington Council for £37,000, which converted it into a hotel.

9. Bennet House

Bennet House, with its perfect Georgian symmetry, has graced Darlington's townscape for more than two centuries, but it has no real history, no obvious significance, no great meaning, no outstanding use and not many original features. But it does look nice. As Pevsner says, 'Bennet House is much altered, but still attractive.'

And by just looking nice, Bennet House saved Darlington from architectural Armageddon.

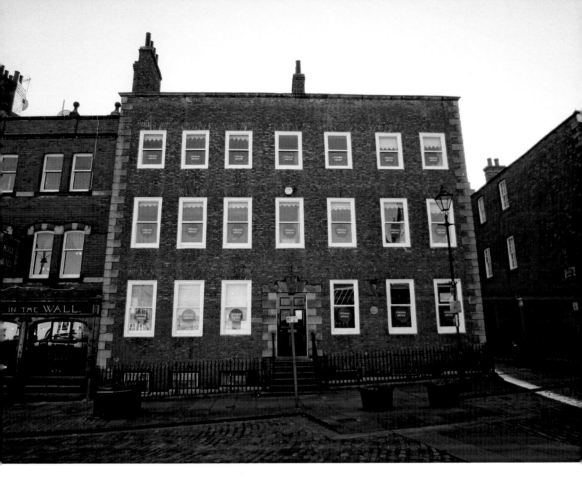

Above: Bennet House, overlooking the Market Place, saved Darlington town centre from the 1960s destruction.

Below: A late Victorian view of Bennet House overlooking the Market Place.

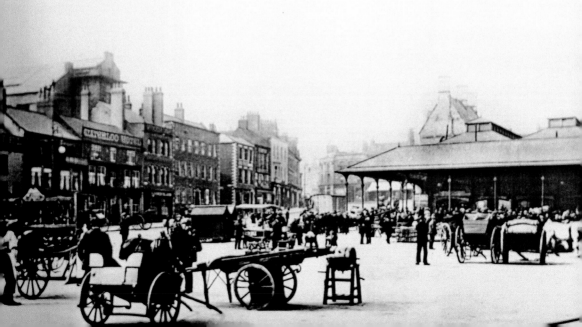

Bennet House overlooks the Market Place, but such is its anonymity in the town's annals that it is not recorded why it is called 'Bennet'. When it was built at the end of the eighteenth century, it went by the bland name of Central Buildings and started life as two, possibly three, townhouses for moderately well-to-do families.

When the gargantuan Central Hall was built behind it in 1846, Bennet House changed its name to Central Hall Buildings and changed its nature from domestic to commercial.

One of the first occupants of its basement was the *Darlington and Stockton Times* newspaper, and above it was the Darlington Subscription Library and an apartment for the librarian.

By 1894 the building was owned by solicitor Edward Wooler. It is said that to widen Bull Wynd from 8 feet 6 inches to 9 feet he dismantled and rebuilt its west wall. If this is true, these must be the most expensive 6 inches of all time – yet the building's brief description on its Grade II* listing notes that its 'right return to Bull Wynd rebuilt in modern brick'.

In 1939, Darlington Council installed the borough treasurer in Bennet House, and, in the late 1960s, devised a hideous plan to demolish it and replace the buildings around it with £2.5 million of brutalist concrete-and-glass boxes. Two planning inspectors in the early 1970s rejected the first Shepherd Plan and its equally unpleasant Tornbohm Plan on the basis that Bennet House, although badly mutilated over the centuries and without historical association or significance, was just too nice to be replaced by brutalist boxes.

So, just by being attractive, Bennet House saved Darlington from desecrations that would have torn out its very heart.

10. Edward Pease's House

When Edward Pease moved into his late eighteenth-century rented house in Northgate in 1798, he was thirty-one and recently married. The house was on the edge of town, with a long garden lined with greenhouses – peaches, nectarines, cherries, apricots, plums, pears – stretching through an orchard to a footbridge over the Skerne.

Within a decade, the family wool business had done so well out of the Napoleonic Wars that he was able to buy the house for £367 10s, and within another ten years he had retired and become embroiled in the planned Stockton & Darlington Railway. On 19 April 1821, George Stephenson and Nicholas Wood called unannounced on him. One version of the story says they had walked the course of the proposed line barefoot to save shoe leather and had used Bulmer's stone opposite to put their shoes on before approaching Mr Pease; another version says that they'd walked the line wearing their shoes, which had become so muddy that they'd taken them off at Bulmer's stone before approaching Mr Pease. Barefoot or not, it mattered not: it was 5 p.m. and they had no appointment, so Edward's butler threw them out.

Edward, upstairs, heard the commotion, came rushing down and invited them into his front kitchen, where a kebab shop is today. There, Stephenson persuaded Pease that his line should be a railroad (with rails above the ground) rather than a tramway (with rails set into the ground), and it should be powered by steam locomotives rather than horses. This is the birth of the railways, although when the S&DR opened on 27 September 1825, around 0.25 miles away, Edward was at home, mourning his favourite son, Isaac, who had died the night before of TB, aged twenty-two.

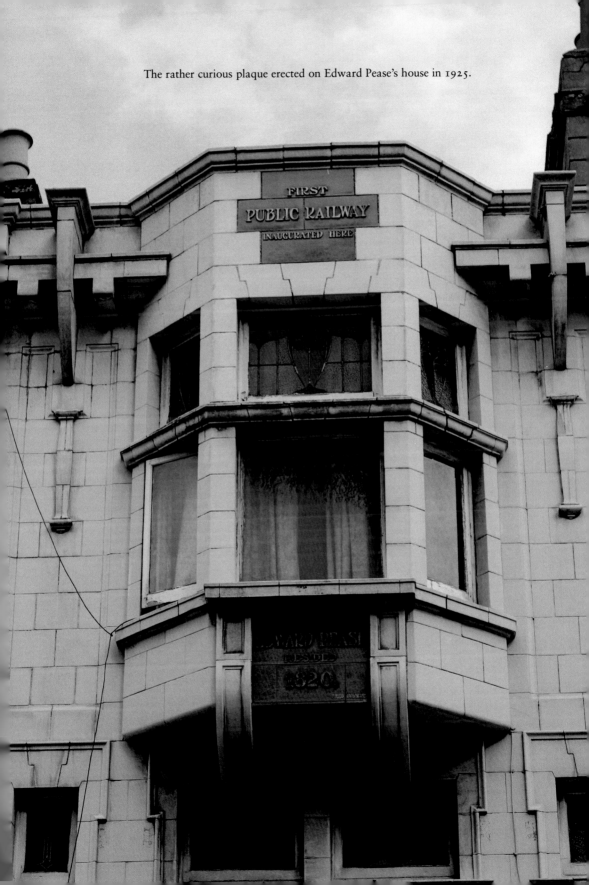

The rather curious plaque erected on Edward Pease's house in 1925.

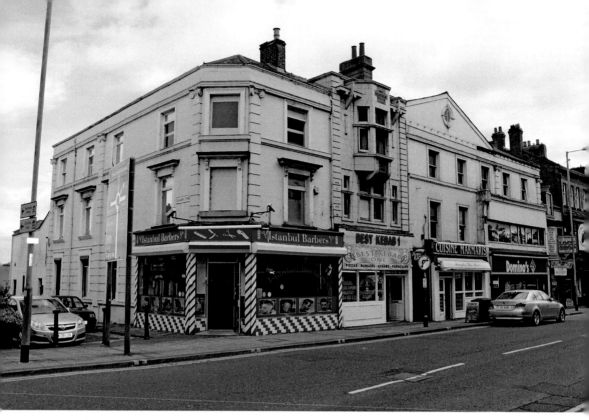

Edward Pease's house is now lost beneath a barber's, two kebab takeaways and a pizza parlour.

It was at the house that Edward himself died on 31 July 1858, aged ninety-one. In 1866, the house was converted into shops and a new frontage was added. Today, amid the gaudy lights and takeaway smells, it is impossible to make out his residence, but standing in the rear car park, which covers his garden, you can see a graceful, arched stair window, which harks back to the time when this was the centre of the railway revolution.

11. Bondgate Methodist Chapel

Bondgate chapel, built in 1812, is big and imposing, a monument to the strength of the Methodists' faith, but hidden away over the road in a pub's backyard, semi-obscured by a fire escape, is the very beginnings of their faith. A bricked-up arched window at an odd height behind the pub bins is the remains of the first chapel, which is so old that John Wesley himself visited it.

Wesley first came to Darlington on 18 July 1743. He rode four hours south from Newcastle to Ferryhill, where he rested for an hour before riding for another two into Darlington, where both horses expired. Despite this Wesley returned in 1745 and found room in an inn, where he was disturbed by the locals' swearing. He did, though, plant some seeds because in 1753 in the Clay Row home of a Mr Oswald, beneath its thatched roof and on its mud floor, the town's first Methodist service was held. As the new religion grew, plans were made for a meeting house and in 1779 a chapel was built at the back of the George Inn. It was 27 feet long, with a gallery at one end that took its seating capacity to 300.

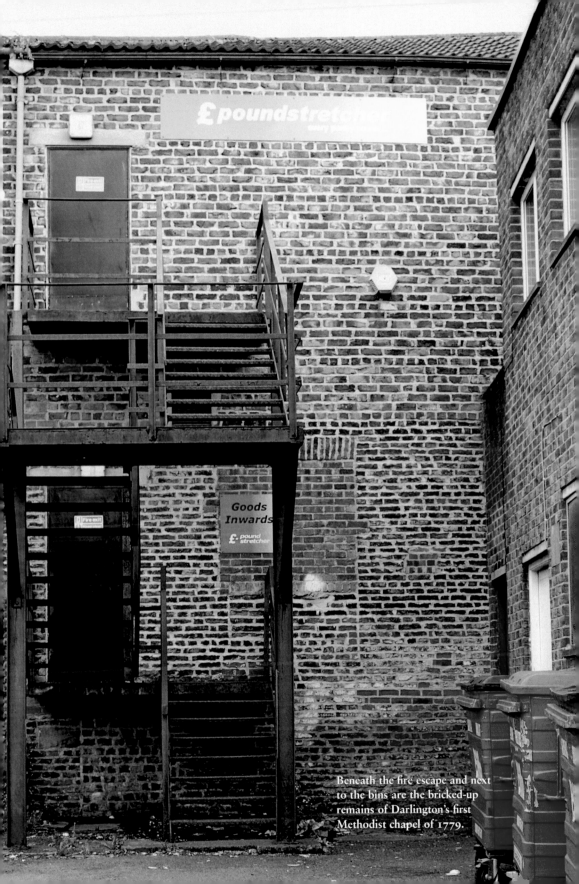

Beneath the fire escape and next to the bins are the bricked-up remains of Darlington's first Methodist chapel of 1779.

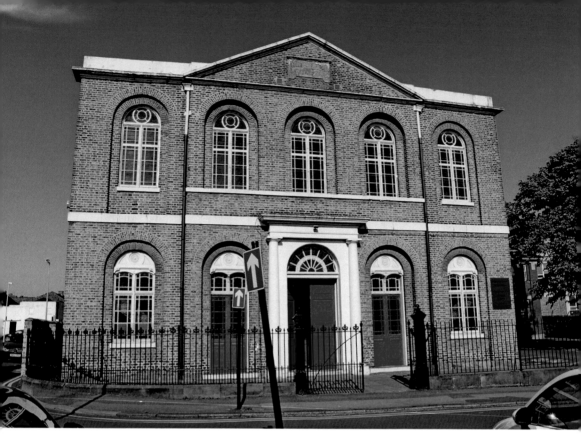

The big and imposing Bondgate Methodist Chapel of 1812.

At the start of the new century, the Methodists bought some land from the Duke of Cleveland in Salt Yard – salt dealer Edward Toff had his premises there – and instructed architect William Jenkins to design an Italianate chapel for £4,000 – his chapels, from Bath and Canterbury to Sheffield and Leicester, all have an Italianate enormity to them. Darlington's, which has '1812' on its date stone, making it one of his earliest, could hold 1,400 people at a time when the town's population was less than 6,000. The first service was held on 4 July 1813, at which point the old chapel behind the pub became redundant. It was sold for £290 and incorporated so entirely into the George that it became lost until it was rediscovered by ecclesiastical historian Peter Ryder in 2004.

12. Polam Hall

In 1794, 'eminent mercer' and linen draper Harrington Lee acquired 4 acres of land at Polam, a pooly place beside the River Skerne on the southern approach to Darlington. He was only twenty-seven, but still wealthy enough to build the town's first countryside villa. With his wife Margaret, a member of the wealthy Hylton family, and his six children, he lived at Polam for more than twenty-five years.

The next owner was banker Jonathan Backhouse Jr (1779–1842), who upgraded Lee's villa into a mansion. He acquired the farms around until he had 36 acres, which he turned into a pleasure garden and parkland, complete with its own fishpond. He also turned the

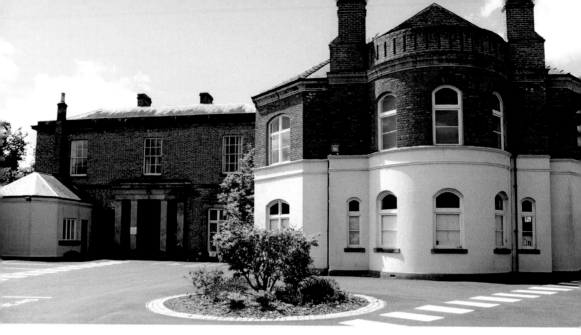

Above: Polam Hall is the first of Darlington's edge-of-town villas occupied by its successful nineteenth-century entrepreneurs.

Below: The pupils and teachers of Polam Hall outside the entrance in 1857.

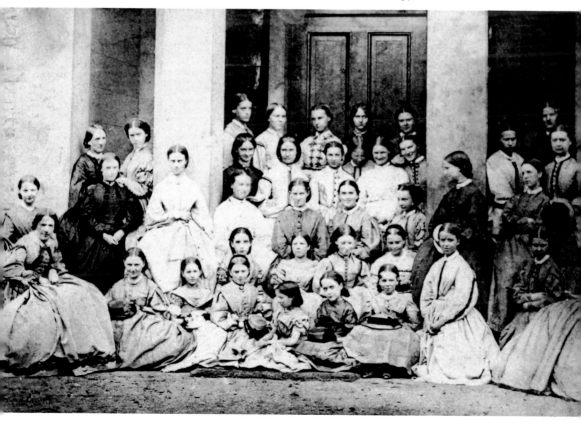

house around so that it looked down through the gardens to the river, with the broad sweep of pasture beyond.

Jonathan's wife Hannah was given the suite of rooms that commanded the best views, although in 1830 she left her four young children at Polam and embarked on five years of uncomfortable Quaker missionary work in the slave-owning states of the US. After her return, she never felt comfortable in the opulence of the hall. On her letters, she wrote her address as Polam Hill, which sounds a little less grand.

On her death in 1850, the estate was sold to the Thompson brothers, William and Robert, accountants and stockbrokers. Four years later, they rented it to the Procter sisters, Jane and Elizabeth, who had been running a Quaker boarding school for young ladies in Houndgate since 1848. The Procters' school remains today, adapting to the times: in 2004, it allowed boys into the sixth form as it slowly became coeducational, and in September 2015 it was granted free school status, meaning that it is now a state school with no fees, but is independent of the local education authority.

13. Dressers of High Row

For a generation, one shop was synonymous with high quality and family service. With its departments selling everything from haberdashery to fountain pens, it positively reeked of old-fashioned ways. Dressers, at the heart of High Row, was Darlington.

Its retailing roots went back to 1783 when John Watkin of Staindrop formed a drapery business, which he moved to Richmond and then to Horsemarket in Darlington before, in 1804, arriving at No. 26 High Row – the shop that was at the centre of the town's most prestigious street. In 1830, Richard Luck of Richmond joined the business, and when Mr Watkin retired it became known as Luck & Sons.

In 1926, Lucks overhauled their landmark premises. On the ground floor was household and fancy linens, haberdashery, hosiery, gloves and handkerchiefs; upstairs was soft furnishing, carpets, linoleum and upholstery. The two were connected by 'a handsome mahogany staircase'. In 1959, Lucks were even more daring, fronting their shop with a pair of space age windows – two glass cubes that apparently floated on High Row.

Meanwhile, around 100 yards north in Nos 41–42 was the printer's established by William Dresser in 1858. By 1942, when his sons sold the business, it had expanded into stationery. Its new owners, Fred Mowbray, a typewriter salesman from Stockton, and G. W. Rudd, a paper merchant from Bishop Auckland, expanded it further, with Peter Warrand as general manager. In 1953, for example, they added a travel department that sold cases for newly fashionable foreign holidays.

In 1965, the last of the Lucks, Richard, sold No. 26 to Dressers for £110,000. Lucks closed on 31 January 1966 and Dressers opened in the larger premises on 14 March, merging haberdashery with stationery and travel, toys, fancy china and glass, plus Pen Corner, all linked by that fabulous staircase.

The Dressers era came to an end on 31 March, 2001, when the shop closed. The space age glass boxes were removed and it was empty until Waterstones took over in 2005. Its stay was short, however, and on 15 May 2008, despite dismay at its inappropriateness, Poundland opened, with its garish turquoise front at the heart of High Row.

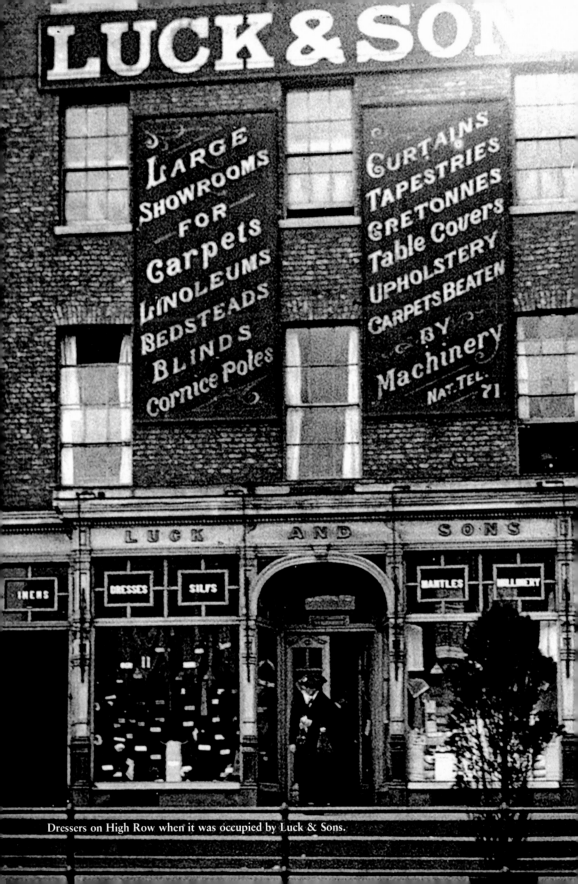

Dressers on High Row when it was occupied by Luck & Sons.

Poundland now occupies the store of Dressers and Lucks.

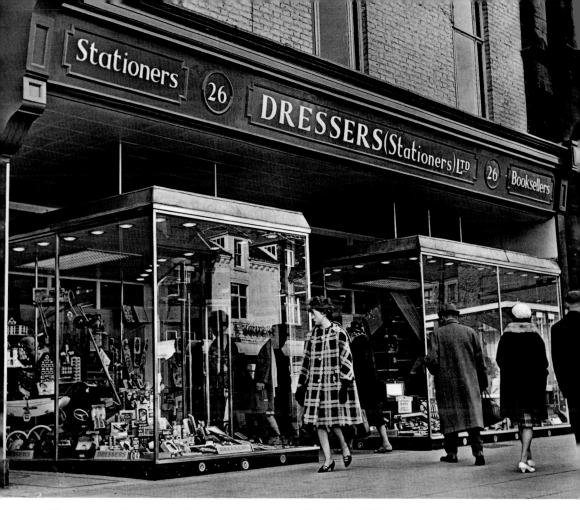

The space-age glass boxes of Dressers that seemed to float above High Row.

14. The Skerne Bridge

The Skerne Bridge has many claims to fame: it was the most substantial piece of infrastructure on the world's first passenger railway, the Stockton & Darlington Railway; it was the world's first railway bridge to be designed by an architect rather than an engineer; it is the world's oldest railway bridge in continuous use; and it graced the back of the £5 note for more than a decade in the 1990s. And it was a cause of friction between the directors of the S&DR and their resident engineer, George Stephenson.

In 1823, Stephenson had bridged the much smaller River Gaunless at West Auckland with the world's first cast-iron railway bridge, which had been washed away by a flood a few weeks after its completion. In 1824 he was commissioned to bridge the Skerne, and he began planning something similar to that over the Gaunless. However, he ran into problems with the foundations and, on 23 April 1824, the directors ordered him to consult Ignatius Bonomi, the Durham county bridge surveyor. Stephenson was obviously reluctant as, six weeks later, the directors reminded him to get the area's bridge expert involved. Bonomi's initial suggestions arrived on 2 July 1824, and Francis Mewburn – the world's first railway solicitor – laid the foundation stone four days later.

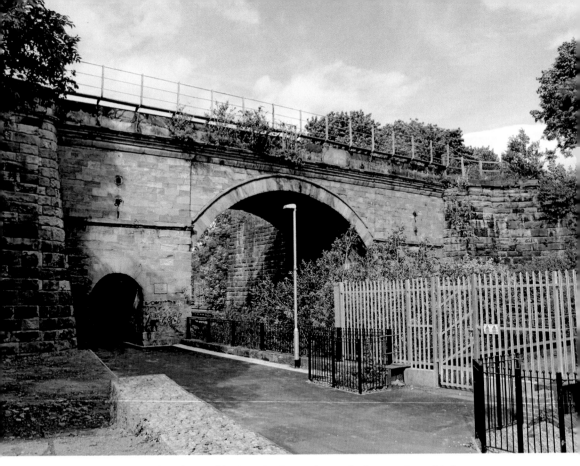

Above: Skerne Bridge, designed by Ignatius Bonomi, was the largest piece of infrastructure on the 1825 Stockton & Darlington Railway.

Below: The famous view of the Skerne Bridge on the opening day of the Stockton & Darlington Railway was painted by John Dobbin in 1875 and is now in the collection of Darlington Borough Council.

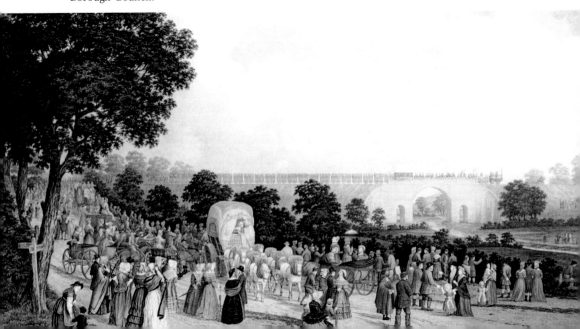

However, Stephenson was persisting with a stone and iron bridge. It was as much the high price of iron as the failure of the Gaunless bridge that persuaded Joseph Pease to seek Bonomi's advice a second time, and the resident Durham Cathedral architect came up with the classical single arch with two smaller arches over the riverbank towpaths, which was in construction in November 1824.

The bridge – initially known as 'the bridge near Nicholson's mill' and 'Helen's Bridge' – cost around £2,300. It features as the centrepiece of John Dobbin's famous painting of the railway's opening day – 27 September 1825 – on which the Bank of England based its £5 note design in 1990.

15. Southend

Southend was a marvellous mansion that was the home of Darlington's greatest son – Joseph Pease. Today it is a luxurious hotel owned by Duncan Bannatyne, the town's most famous resident.

At the beginning of the nineteenth century it belonged to the Backhouse family of Quaker bankers, who called it Burrowses because it stood at the south end of the borough. When Joseph Pease (1799–1872) bought it in 1826, he adapted the name and then adorned the estate. He added a third storey to the house, along with a nursery wing, a large bay

Joseph Pease's Southend mansion is now at the heart of Duncan Bannatyne's New Grange Hotel.

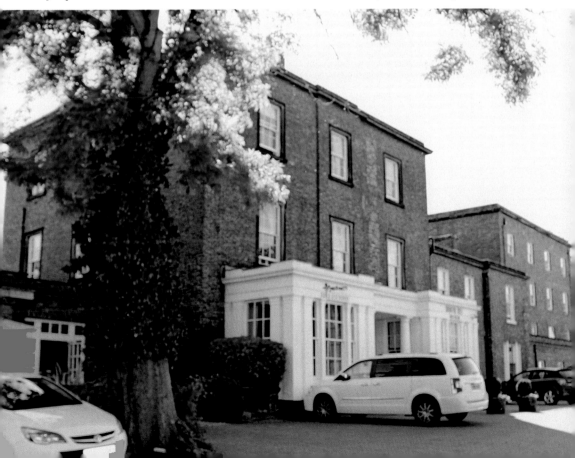

window, the redoubtable entrance portico and a conservatory in which he kept forty canaries. He added fields around the gardens so that he owned 27 acres in total, on which he had five summerhouses, two fountains, several ponds and a variety of temples, louvres, alcoves and even an ornamental paddock house.

It was a property fit for the town's greatest son. In 1819, Joseph had prepared the prospectus for the Stockton & Darlington Railway. Then in 1829 he had sailed among the desolate salt flats at the mouth of the Tees and imagined a port bustling with ships – he had founded Middlesbrough. In 1833, he became south Durham's first MP – the first Nonconformist MP for 200 years.

He was a man of enormous industry: when he died in Southend on 8 February 1872, his mines were producing more than 1 million tons of coal a year, and he left a personal fortune of £320,000. In 1875, his likeness was erected on the town's only statue, in High Row.

The creep of West End housing across Joseph's estate began after his death, although his Crocus Walk along Grange Road became a public space in 1901. In 1904, his mansion was converted into the School of the Immaculate Conception – a Roman Catholic grammar school for girls – and it remained a school until 1974, when the girls merged with the boys to form Carmel College.

In 1978, Southend became the New Grange Hotel, which now is known as the Bannatyne Hotel Darlington as the home of the great nineteenth-century entrepreneur is owned by a twenty-first-century dragon.

16. The Railway Tavern

The Railway Tavern in High Northgate is probably the oldest purpose-built, continuously operated, railway-related pub in the world, although in 2009 English Heritage said it had been too bashed about to be worth listing.

As the coal-carrying Stockton & Darlington Railway opened in 1825 without provisions for passengers, it was soon realised that trackside assembly points would be a boon. John Carter, the S&DR's Inspector of Works, was asked to build three: one near the Stockton terminus, one at the Aycliffe Lane level crossing, and a third on Northgate. The three properties were to act as waiting rooms, parcel booking offices and ticket offices, with the sale of beverages providing useful income; however, the Quakers running the railway only allowed the sale of weak 'small beer' and banned spirits.

The Stockton Railway Tavern opened in October 1826 (it was converted into a house in 1867), but the other two premises were in the domain of Darlington magistrates who, under pressure from rival publicans, refused to licence them. The railway company successfully took its cases to the Durham Quarter Sessions in October 1829, after which the inns fully opened. To ensure there was always beer on tap in Northgate, even when the rival publicans were being awkward, a microbrewery was established at its rear.

The inn was strategically placed overlooking the coal depot branch line and is said to have been deliberately set back from the road so that carts could be parked outside while their carters were refreshing themselves inside – it could even be seen as the world's first railway station car park.

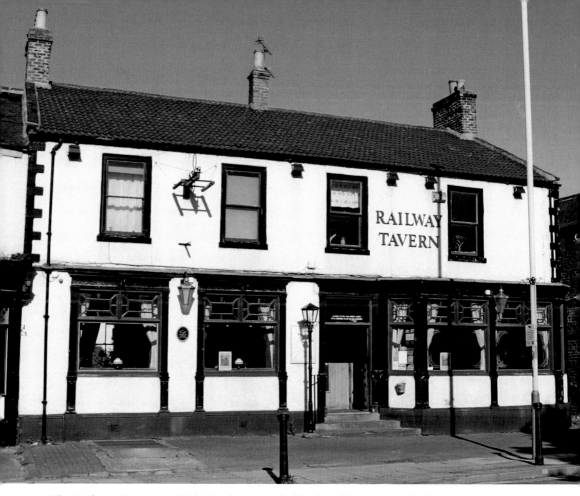

The Railway Tavern on High Northgate: probably the oldest, purpose-built, continuously operated, railway-related pub in the world.

17. St Augustine's Church

In 1989, English Heritage said that the fifth stage of the Darlington inner ring road, which would complete the loop from Bondgate through to Victoria Road, should not go ahead because the clearance of Larchfield Street would expose St Augustine's to full view. The heritage organisation's expert witness told the government inquiry: 'This Roman Catholic church was built before Catholic Emancipation in 1829 and so was strictly illegal. The practice of such activity would have been discreetly hidden away, so opening it up destroys its historical context.'

Now, it is true that Catholics suffered terribly at times in Darlington – in 1801, for instance, the Bishop of Durham said there were forty-eight people 'perverted to Popery' in the town. But by the time St Augustine's was built, the Catholic community was too well cemented to be secretive. They'd first met in William Ridsdale's heckle-making workshop (where Binns is today on High Row), and in 1786 had built their first chapel in Slater's Yard, Bondgate. By 1805, it was too small, and so a 150-seater chapel was constructed behind Mr Ridsdale's house in Paradise Row, Coniscliffe Road.

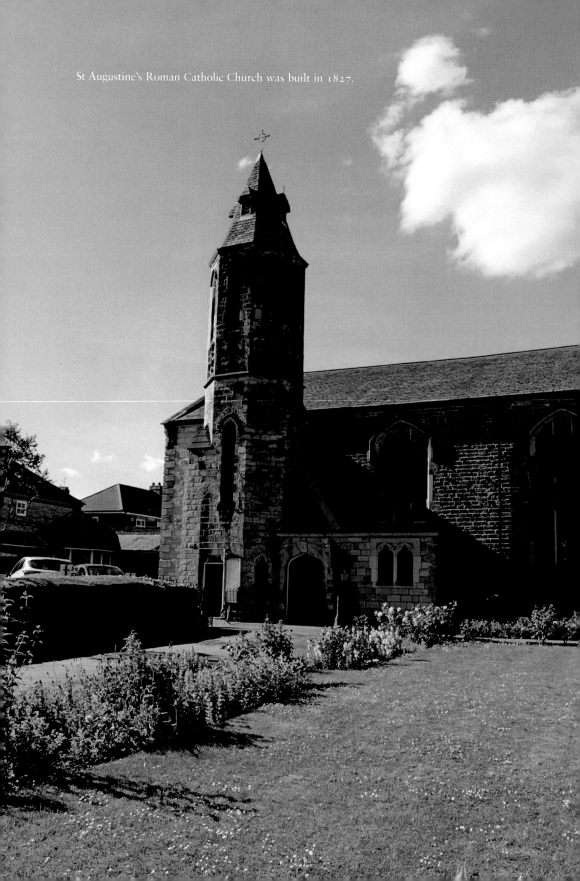

St Augustine's Roman Catholic Church was built in 1827.

But with toleration growing and Father William Hogarth ministering to the flock from 1823, numbers continued to grow. In June 1825, Hogarth paid the Earl of Darlington – William Vane of Raby Castle – £55 for a portion of the Green Tree Field next to the existing chapel. He called in Ignatius Bonomi, the renowned Durham architect, to produce an early Gothic design to hold 450 people.

It is said that as fast as the church was built, a 'Black Gang' would nightly pull the stones down, but with such a big church being built by the county's leading architect on land purchased from the area's most important Protestant nobleman, this was hardly a clandestine operation.

The 1805 chapel was demolished – one curved wall and an urn may survive – to create the lawn in front of the new one, which was dedicated on 29 May 1827.

Despite the expert witness' inaccuracy, his evidence helped defeat Stage V, which inspired the congregation to embark upon a major restoration and it enabled the tranquil ambience of St Augustine's to survive.

18. Pierremont

The home of Henry Pease was so opulent that it was known as 'the Buckingham Palace of the North' – although to his father, Edward, it was 'that showy mansion'. It was initially created by builder John Botcherby, who developed the suspiciously made-up sounding name of Pierpont, which somehow translates as 'the house on the hill overlooking the Cocker Beck'. Botcherby lavished a fortune upon it, even installing large windows with grandiose Bs in the coloured glass, while swearing that no Pease would ever own his home.

But pride always comes before a fall. John had over-extended, and was forced to sell Pierpont to currier John Bowman in 1844 for £3,800 – a huge loss. The following year, Bowman sold 'Pierremont' on to Henry Pease (1807–81) for £5,000 – a gigantic profit.

Henry, who drove the railway line over Stainmore and founded Saltburn as the first railway resort, lavished a further fortune on Pierremont. Initially, he contented himself with the 28 acres on the north side of Woodland Road based on the steep banks of the Cocker Beck. Then, in 1864, he bought a quagmire to the south and transformed it in Pierremont South Park, which he opened to the public from 1870. In the first six years 10,000 visitors flocked

Pierremont, completed by Alfred Waterhouse for Henry Pease, was Darlington's most sumptuous mansion with its fernery, on the right, and its clock tower.

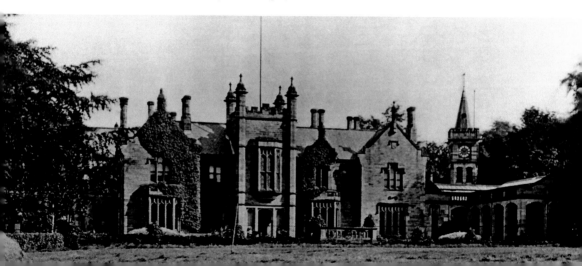

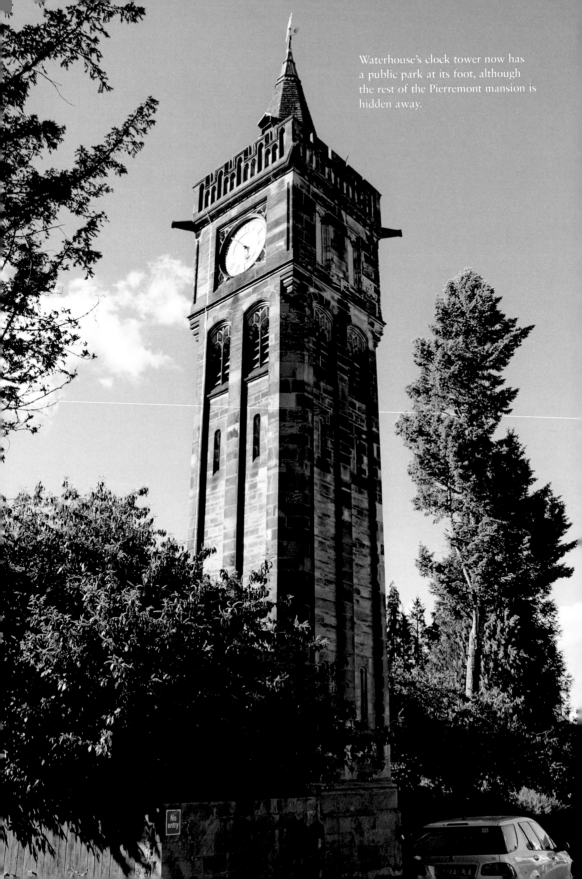

Waterhouse's clock tower now has a public park at its foot, although the rest of the Pierremont mansion is hidden away.

to see it – some brought by special excursion trains. They marvelled at everything from the carpet bedding – 10,000 plants blooming artistically away – to the Pierremont Vase, the finest fountain in the north of England (now in Darlington' South Park) with twenty-eight jets playing away. There was a serpentine lake crossed by an ornamental bridge, completed by an island that was topped by a Swiss chalet and an Alpine garden. A rocky grotto concealed a boathouse, a heated garden party room and a secret passageway underneath the waterfall.

And in the background was Pierremont itself, its crowning glory being the clock tower added in 1873–74 by Alfred Waterhouse, the greatest Gothic architect of his generation.

Henry died in 1881, and after his second wife, Mary, died in 1909, the pleasure ground was sold for housing, the mansion was divided into five separate homes, and the clock tower was presented to the town as a small public park.

19. Holy Trinity Church

In 1821 Darlington's population was 5,730. By 1841, the railways had driven it up to 11,025. And yet there was only the one Anglican church, St Cuthbert's; it was so full that it was in danger of collapsing – quite literally.

So on 8 October 1836, the new Bishop of Durham, Revd Edward Maltby, laid the foundation stone for the first new Anglican church for 600 years in a field off Cockerton Lane. It was designed by Anthony Salvin, whose family had been connected with Croxdale Hall at Sunderland Bridge, near Durham City, for centuries, and who himself became famed for repairing castles, including Durham, Alnwick and Windsor

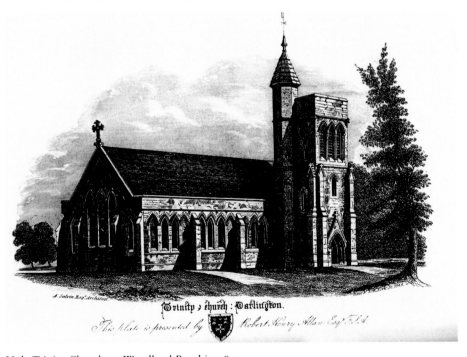

Holy Trinity Church on Woodland Road in 1849.

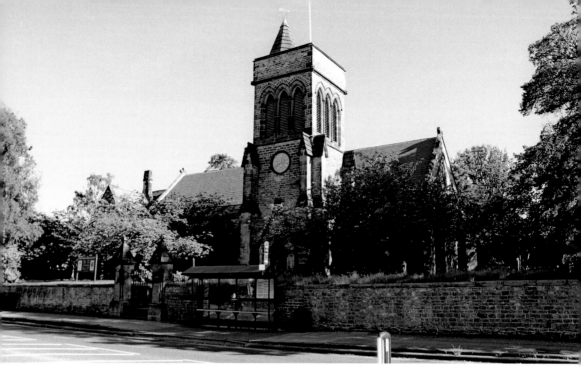

Holy Trinity Church on Woodland Road.

Bishop Maltby returned on 6 December 1838 to consecrate the £3,404 church, which could seat 1,010 people. Internally, it was an old-fashioned Georgian 'preaching box' – a simple, functional oblong nave where the emphasis was on every parishioner being able to see and hear. Externally, its Gothic Revival architecture was a throw forward to the grandiose style of the Victorian era. It didn't even have its own altar because, until 1843 when it got its own parish, it was just a chapel of ease to St Cuthbert's.

In 1865, Holy Trinity's second vicar, Revd Thomas Webb Minton, retired at the age of seventy-four and donated much of the £2,000 needed to add a chancel to the preaching box. Mr Minton was from the famous pottery family firm of Stoke, which donated a fine floor of encaustic tiles to go in the Minton chancel.

In 1900, the chancel was extended by a further 6 feet eastwards in memory of Edward Thomas Pease, whose black sheep branch of the teetotal Quaker family had become Anglican wine merchants. Having been a member of the congregation for thirty-five years, Edward left £4,000 to create the shape of the church that survives to this day.

20. The Lime Cells

Today, the boarded and barricaded lime cells don't look very much at all. They haven't had a proper use for a couple of decades, but if you look carefully on the upper floor – a graceful arch in the brickwork and carved stone bands at the top of the delicate pillars – you can see back to the early railway days when they were important.

When the Stockton & Darlington Railway opened in 1825, a little branch line ran down a natural incline to Westbrook coal drops, where the coal was tipped out of the trucks into the carts of merchants below. The branch line also served the lime cells, built in the 1840s. Limestone (calcium carbonate) was mined in Weardale, heated in a kiln to create quicklime (calcium oxide) and then, while still hot, sloshed with water to produce slaked

Above: The lime cells on Hopetown Road don't really look very much in their current derelict condition.

Below: The upper storey of the lime cells, hidden among the trees, hint at the building's important past.

lime (calcium hydroxide). This was crushed in a pug mill to create a white powder that was sent to the lime cells. The wagons entered the upper level of the cells, a hatch opened in their floor and the lime plunged 12 feet into the bays below, where builders collected to make either mortar or plaster for the houses that were springing up due to the railway expansion. The cells fell out of use at the end of the nineteenth century.

Despite their dereliction, the cells are a unique example of local industrial architecture, designed because, unlike coal, lime is damaged by rain and so the cells had to be roofed. Bottom-emptying wagons were used, though, so the railway didn't have to pay a shovelman.

21. North Road Station complex

On 27 September 1825, the opening day of the Stockton & Darlington Railway, George Stephenson stopped *Locomotion No. 1* in the countryside north of Darlington, where the line crossed the Great North Road so that coal could be distributed to the poor. At this crossroads, the first station grew up. A wooden shed was erected to the west in 1827 and around the same time, a three-storey stone goods warehouse was built to the east, leaning against the railway embankment. This is regarded as the world's first railway station, but, because it was so tall, it never handled heavy goods with ease. In 1833, it was converted for passenger use and a single-storey merchandise station was built to the west of the level crossing. It was designed by Thomas Storey, the S&DR's first resident engineer, and was expanded in 1839–40 by his pupil John Harris, who added the distinctive clock tower.

Access to the goods delivered to the merchandise station was controlled by the 1840 Goods Agent's office in McNay Street.

North Road station is today a railway museum.

The merchandise (or goods) station from 1833 is the oldest surviving station in Darlington.

Harris next created a single-storey passenger station to the west of the level crossing, which he completed in April 1842. It had a grand entrance portico, but, typical of the penny-pinching of the early railway days, it provided a roof for three tracks so that the central one could act as a siding for carriages, thus avoiding the expense of a carriage shed.

As lines to Teesdale and Weardale were opened from the 1850s, North Road station expanded, and in 1876 a second floor was added to accommodate telegraph equipment.

However, as the East Coast Main Line developed, it turned out to be in the wrong place, and from the 1890s its future was in jeopardy. The closure of the branch lines in the 1960s increased that jeopardy, but imaginative townspeople rescued it and on 27 September 1975 – the 150th anniversary of the S&DR – the Duke of Edinburgh opened it as a museum.

In 1983, Darlington Council acquired the merchandise station and with the Goods Agent's office, the two stations make up a remarkable triumvirate of the earliest railway buildings.

22. Haughton Road Engine Shed

When this derelict railway building beside the East Coast Main Line was granted Grade II-listed status in 2008, English Heritage described it as 'a rare surviving example of a first generation railway engine shed and it is highly significant for the evolution of early railway building design'. It gives a unique insight into the hotchpotch nature of early railway development.

The first stretch of mainline was built by the Peases' Great North of England Railway (GNE) from York's splendid station to a shed at Bank Top, Darlington. It opened on March 30, 1841, and GNE had a shed nearby in which to house its engines.

The second stretch of main line was that of George 'the Railway King' Hudson's Newcastle & Darlington Junction Railway (N&DJR), which opened on 15 April 1844, running from the passengers' shed at Bank Top up to Gateshead.

An accident of history has enabled the Haughton Road engine shed to survive from 1841.

In those pioneering days, the N&DJR and the GNE were completely – albeit briefly – separate companies. Each company used its own engines to haul a train across its own track, so, on 16 August 1844, the board of the N&DJR instructed renowned architect George Townsend Andrews to build it a shed off Haughton Road.

But as soon as the mortar had set, on 1 July 1845, Hudson united the two companies and scrapped the handover, so the brand new shed became redundant. It stood a forgotten footnote until 2004, when British Rail sold it for £620,000 to a developer in the British Virgin Islands, which planned to demolish it. However, after it became Grade II listed, the plans were revised so that it was to be converted into apartments with a railway-themed estate around it.

23. Tees Cottage Pumping Station

There's a subterranean rhythmic rumble accompanied by a trebly hiss of escaping steam on the downbeat, but the tons of machinery move almost noiselessly from floor to ceiling, from way overhead to deep down below. The governor twirls like a ballerina performing an endless pirouette, while the 17-ton flywheel spins effortlessly as, up in the rafters, the 25-ton beam hypnotically nods backwards and forwards and backwards and forwards and...

There can be few better sights in Darlington than the Edwardian finery of the pumping station in full steam. Its most eye-catching feature is the beam engine, built locally by Teasdale Brothers in 1904, and still fired by its original 1902 Lancashire boilers. It was one of the last waterworks beam engines ever built, so it represents the peak of this type of engineering.

Cognoscenti reckon the 1914 internal combustion gas engine is the most important element of the site. Built by Richard Hornsby & Sons of Grantham, it is the largest surviving engine of its type still working in Britain, and probably in Europe.

The site goes back much further than the engines, though; to 1847 when the Peases formed the Darlington Gas & Water Co. to suck up Tees water and filter it, then pump it into the disease-riddled town centre. When the first water arrived, on Wednesday 24 April 1850, the townspeople were sceptical, of both its quality and the Peases' motives.

When it was discovered that 'the beer was better and the tea stronger' with the new water, some misgivings evaporated, but in 1854 the Board of Health – controlled by the

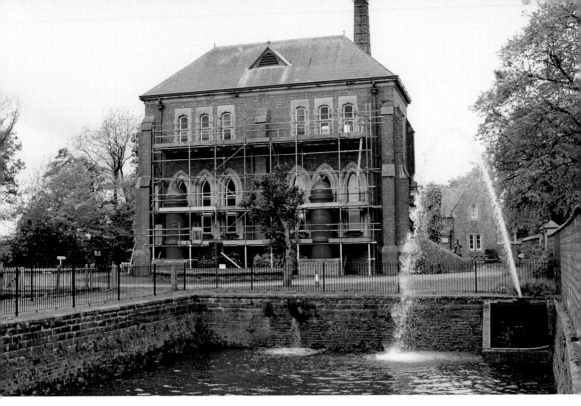

Above: The Tees Cottage Pumping Station of 1849.

Below: The great beam at the top of the Tees Cottage Pumping Station.

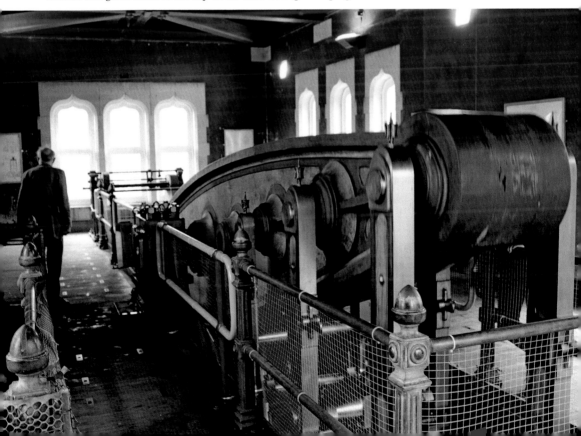

Peases – took over the company and paid the shareholders – nearly all Peases – £54,000 in compensation. The Peases were condemned for 'unbridled profiteering' on something as basic as clean water.

As Darlington's population grew, so the station expanded. The 1904 beam engine enabled it to pump 2.4 million gallons of water a day, and its boilers burned 6 tons of coal. In 1914, the gas engine was installed, followed by a switch to electricity in 1926. The works came under the control of Northumbrian Water in 1974 and stopped pumping in 1980. The station is now maintained by a trust and is open to the public five weekends a year.

24. Hopetown Carriage Works

Railway buildings are often functional and unprepossessing. The Hopetown Carriage Works are utterly functional: two long single-storey wings either side of a two-storey tower of offices. They are utterly unprepossessing, partly because they were derelict for a century and partly because much of their planned ornamentation was stripped away when their architect died young.

But they are probably the oldest surviving carriage works in the world. They are part of the most historic railway triangle in the world. And in them was constructed *Tornado*, the first main line steam engine to be built in Britain for fifty years.

The carriage works were built in 1853 by Joseph Sparkes for the Stockton & Darlington Railway. Sparkes was a local Quaker architect responsible for the Friends Meeting House and Mechanics Institute (both in Skinnergate), but he died in 1855, aged thirty-eight, and the carriage works appear to have been completed by his apprentices, John Ross and William Richardson.

After thirty years, carriages had outgrown the carriage works and production was transferred to York with the loss of 322 jobs. The works were used largely for storage until, in the late 1980s, they were sold to Darlington Council. The building was restored with the help

Hopetown Carriage Works date from 1853 but are now the home of the famous steam locomotive *Tornado*.

of the Lottery so that, in 1997, the A1 Steam Locomotive Trust could build its Peppercorn A1, 60163 *Tornado*. It was completed in 2008 and quickly became a TV star. Currently, a second engine, a Gresley P2, to be called *Prince of Wales*, is being built in the works.

25. Mechanics Institute

The Mechanics Institute is a splendid building that would grace any main street, let alone a backwater like Skinnergate, but the truth is it has been a white elephant for nearly all of its 160 years.

It was formed in 1825 with the laudable intent of educating 'rude mechanicals' – anyone who worked with their hands. Books were collected and a library formed, but, despite having more than 150 members, it soon folded. In 1838, the concept was revived and meetings held in Betty Hobson's Yard, which is now called Mechanics Yard. By 1850, it had 341 members and 1,367 books in what was the town's first public-access library.

All the town's leading names helped move it into proper premises. Elizabeth Pease, for instance, donated £400 and so was asked to lay the foundation stone on 12 May 1853 – 'the silver trowel was judiciously contrived to serve as a fish slice and was presented to the lady'. Elizabeth was a formidable woman, full of feminist passion for working-class movements like Chartists. At the ceremony, her cousin, Henry Pease, and her fiancé, Dr John Pringle Nichol, professor of astronomy at Glasgow University, gave stirring speeches about the importance of education for the working man. Ten days later, in an independent

The Mechanics Institute of 1854 is opposite architect Joshua Sparkes' other major building, the Friends Meeting House.

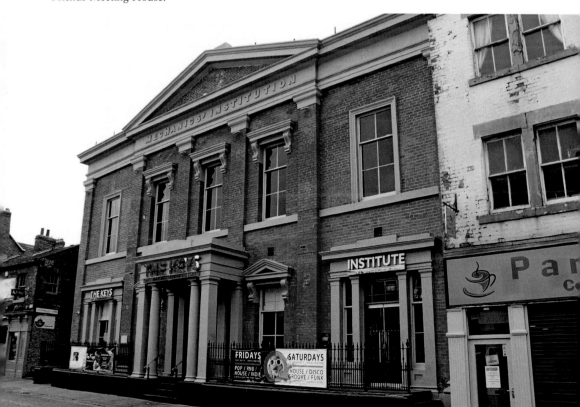

chapel off Northgate, Katherine married Dr Nichol, an Anglican, and was disowned by the Quakers. She left for Glasgow, never to return – although her renowned husband came back in 1854 to lecture on the Immensity of Creation in her newly completed institute.

The building was designed by local Quaker Joshua Sparkes, who was also responsible for the Friends Meeting House opposite. Membership peaked in 1854 at 524 – 3 per cent of the town's population, making it more popular than similar institutions elsewhere. But most working men wanted beer, not books, at the end of a day's toil, so it laboured to pay its debts. It laboured throughout the twentieth century until, in November 2014, the Institute took its snooker tables elsewhere and the building reopened as the Keys, 'a restaurant and entertainment destination'.

26. St Clare's Abbey

Darlington had two religious institutions founded by nuns who fled the French Revolution. The first to arrive were the Carmelites, who were driven from the Continent in 1794 and stayed at Cocken Hall, near Durham, until 1830, when they spotted that Cockerton Field House was empty on the west of Darlington.

The house was the neighbour of Hill Close House, and nearly as old, having origins back to 1650. In 1818, an estate agent described it as 'a commodious mansion, seated in a park-like paddock, relieved by a large sheet of water, and approached by a carriage drive through a thriving plantation'. The nuns enlarged it into a convent and, in the late 1840s, added a chapel designed by the noted Catholic architect, George Goldie of Sheffield.

In the 1850s, the Carmelites sold the southern 20 acres of their estate for £2,000 to nuns from the Order of Saint Clare – known as the Poor Clares. They had fled Rouen in 1795

St Clare's Abbey was designed by the man who invented the hansom cab.

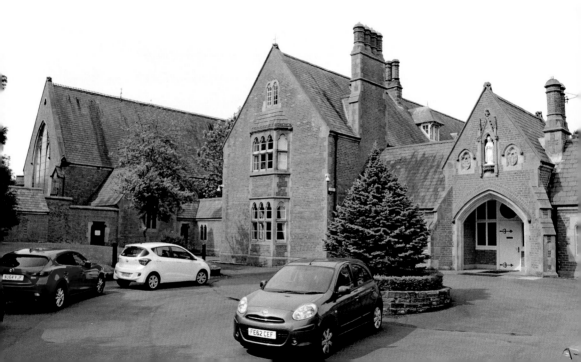

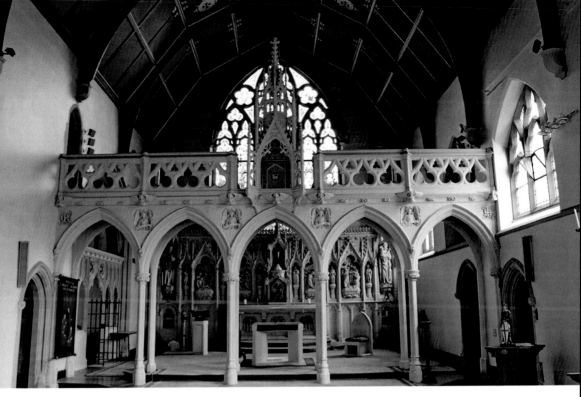

The chapel in St Clare's Abbey.

and, after a decade at Haggerston Castle in Northumberland, had purchased Scorton Hall in Scorton. The move to Darlington enabled them to get another noted Catholic architect, Joseph Aloysius Hansom, the inventor of the hansom cab, to design them a purpose-built abbey. Construction took place from 7 April 1856 to 14 November 1857, although most Darlingtonians have never breached the forbidding brick wall on Carmel Road that kept the contemplative closed order safe.

In 2010, the last four Carmelite nuns left their convent on Nunnery Lane for a 1930s house in Cleveland Avenue. The 3.16-acre site was marketed with a guide price of £1.65 million, and was taken on by the Vincentian Congregation of India, a Charismatic Catholic community whose headquarters, the Potta Divine Ministry in southern India, is the world's largest Catholic retreat.

The last eight Poor Clares nuns left their abbey to join their fellows in Hereford in 2007. The abbey was given to the brothers of the Hospitaller Order of Saint John of God, who had run hospitals in Scorton and Hurworth. In 2012, they were granted planning permission to create a sixty-bed nursing home and an eleven-bed care home in the abbey and now, behind its wall in a large, quiet green space of mature trees and overgrown gardens, it awaits its future.

27. Covered Market

Worried by the effects of pollution on the outdoor market, Darlington's first vaguely democratic council, the Local Government Board of Health, proposed the construction of a covered market in the late 1850s. It was to go on the site of the 1808 town hall and the 1815 shambles.

But the Board – dominated by Liberal Quakers of the 'Pease Party' – rejected the designs of local architects and awarded the contract to Alfred Waterhouse, a thiry-year-old Mancunian

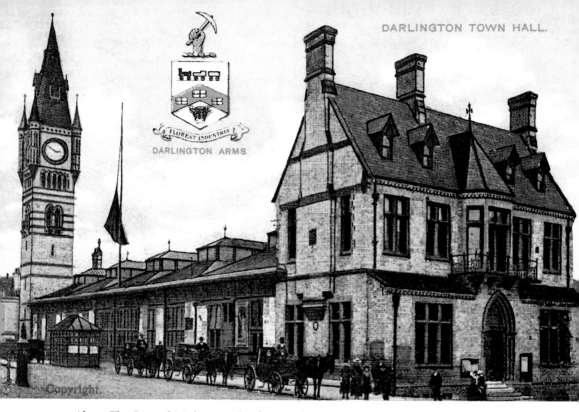

DARLINGTON ARMS

FLOREAT INDUSTRIA

Above: The Covered Market complex from High Row on an Edwardian postcard.

Below: The Covered Market complex was designed by Alfred Waterhouse, who became the greatest Gothic architect of his generation.

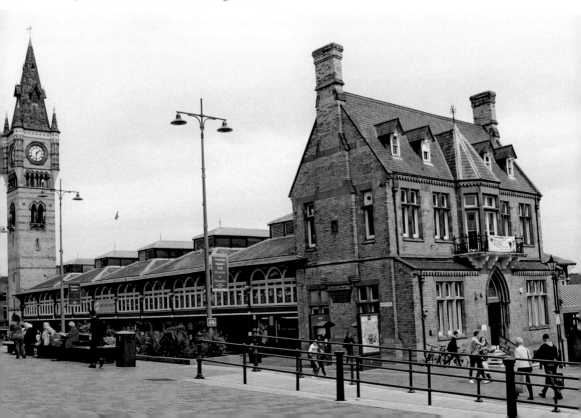

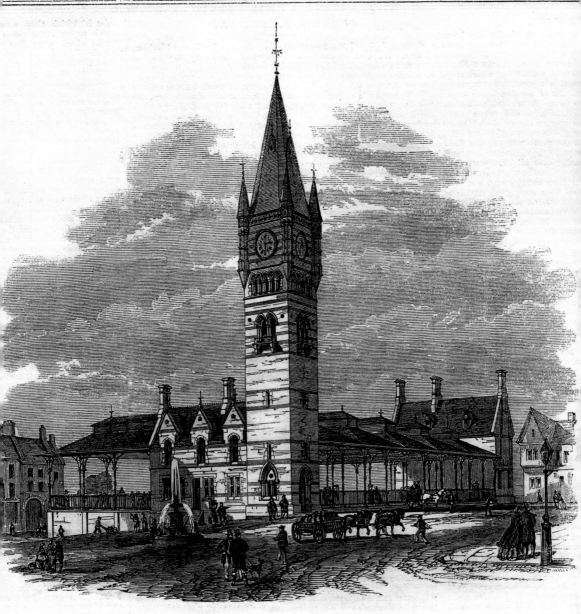

NEW COVERED MARKET AT DARLINGTON.

Illustrated London News' view of the Covered Market complex shortly after it opened in 1864.

who, by coincidence, was a Liberal, a Quaker and related by marriage to several members of the Pease Party.

His initial design came in at £14,000 – around three times more costly than the local architects – and he was forced to scale it back to £7,815. Still, the *Darlington Telegraph* said the complex would be 'a monument to folly, extravagance and jobbery', and local builders refused to tender.

Therefore, Londoner Randall Stap, who had just completed a market in Staffordshire, began work in early 1862. By 10 December 1863, the clock tower was only head-height, but the market itself was complete enough for the Northern Counties Fat Cattle and Poultry Society to hold its prestigious annual show.

But, part of the floor gave way, causing three very fat cattle and ten men to plummet 12 feet into the cellar beneath. Farmer Robert Robson of Newton Morrell, near Barton, broke his leg so badly he died two days later. At his inquest the jury concluded that he died because the metal floor girder 'was not of sufficient strength to bear the weight placed upon it'.

Mr Waterhouse was to blame. But the Pease Party called in their railway engineers who, after much analysis, exonerated the architect and found a little ironfounder, Mr W. Hodgson Davison, culpable for rolling a flaw into the beam.

Trading eventually began at 7 a.m. on 2 May 1864, when John Wrightson bought a leg of mutton from Jack Crawford.

The final bill came to £9,851 and Mr Waterhouse became the greatest Gothic architect of the Victorian era, with the Natural History Museum in South Kensington being his greatest triumph. Darlington market was his only building to fail – and never again did he dabble in cast iron.

28. Town Clock

Pevsner is rather dismissive of the covered market complex's clock tower with its 'somewhat bulgy spired top', but it is now the icon of Darlington.

It was the brainchild of Joseph Pease, who looks at it from his statue. Some say he was inspired by chateau clocks that he'd seen on holiday in France; others that as he was South Durham's MP when Parliament discussed the rebuilding of the Palace of Westminster, he was inspired by Big Ben.

Perhaps because of the unpopularity of the market complex, Mr Pease personally gave between £500 and £1,000 for the construction of the clock tower – 'what a sum to pay for an encumbrance!' wrote Francis Mewburn, Mr Pease's close friend and solicitor, in his diary.

The tower was designed by Alfred Waterhouse and built immediately after the market hall and town hall were complete. The bells, cast by John Warner of Norton-on-Tees, who made the original Big Ben in 1856, were hoisted up the clock tower on Saturday 23 July 1864 and tested: 'the sonorous sounds quite startling the residents in the peaceful locality of the hall'.

The clock was made by Thomas Cooke of York – it was wound by hand, seventy turns on a huge handle, three times a week until electrification in 1977 – and the clock faces are 7 feet in diameter. They were originally illuminated by naphtha gas, although during the trial lighting on 26 September 1864, at 11 p.m. the two experimenters tipped over their bucket of naphtha and set fire to the wooden floor on which they were standing and the wooden ladder up which they had climbed.

The crowd below, waiting to see the first Darlington illumination, passed buckets of water from a fountain to the top. 'We understand that the man who took the principal part in extinguishing the flames was burnt about the hands,' reported the *Darlington and Stockton Times*.

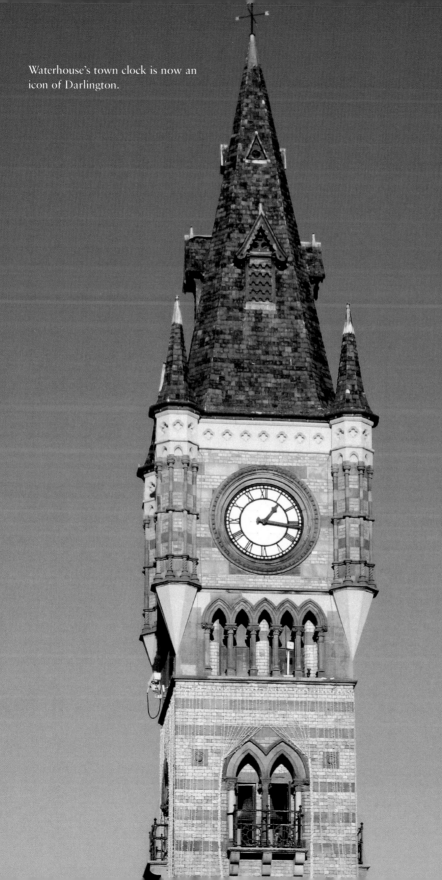

Waterhouse's town clock is now an
icon of Darlington.

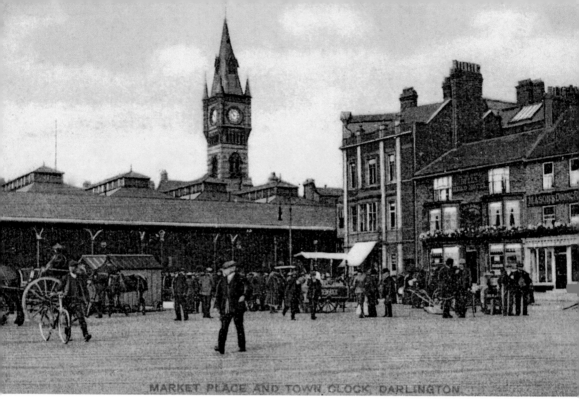

MARKET PLACE AND TOWN CLOCK, DARLINGTON

The town clock viewed from the Market Place on an Edwardian postcard.

Originally, the clock faces were red and the hands were golden. Naphtha gas burned with a greenish hue, causing the townspeople to nickname the new complex 'Dracula's Castle'. They struggled to see the time, so Mr Pease again dipped into his pockets for new white dials.

29. Backhouses Bank

Backhouses Bank on High Row (now occupied by Barclays) looks precisely as a bank should look: powerful, grand and dependable without being frivolous or wasteful. Designed by Alfred Waterhouse, who was simultaneously constructing Rockliffe Hall in Hurworth for the head banker, Alfred Backhouse, work started in August 1864 when the market complex opposite was nearing completion.

Twenty months later on 21 April 1866, the *Darlington and Stockton Times* reported how the final touches were being put to the £12,185 bank: 'Surely no one can look on the magnificent building, which now rears its head with such lofty grandeur, and feel disappointed. As a specimen of the 13th century Gothic style of architecture, it would be difficult to find its equal in the district.'

The bank had been established in 1774 by Quaker linen manufacturer James Backhouse and his eldest son in Northgate, near the old post office. In 1815, the only other bank in town – Mowbray, Hollingsworth & Company, of Durham – collapsed, and Backhouses moved into their premises in the centre of High Row.

It was from there that Jonathan arranged the finance for the Stockton & Darlington Railway, and it was his son, Alfred, who commissioned Waterhouse to create a banking citadel appropriate for such an important town.

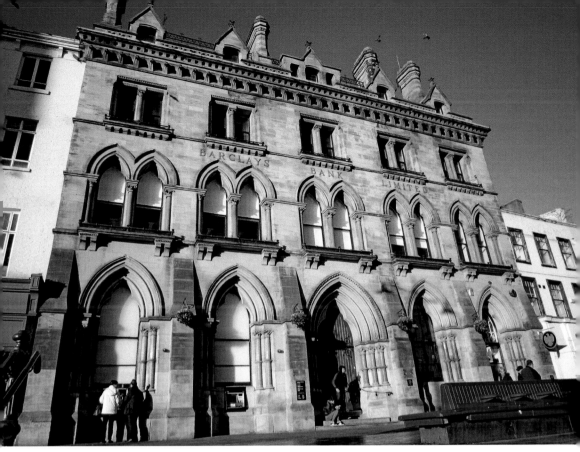

Above: Waterhouse designed Backhouses Bank, now Barclays on High Row, at the same time that he was working on the first phase of Rockliffe Hall in Hurworth for head banker Alfred Backhouse.

Below: Backhouses Bank in the centre of High Row with the Joseph Pease statue, right, looking towards his Town Clock with a spider's web of overhead electricity wires to power the tram network.

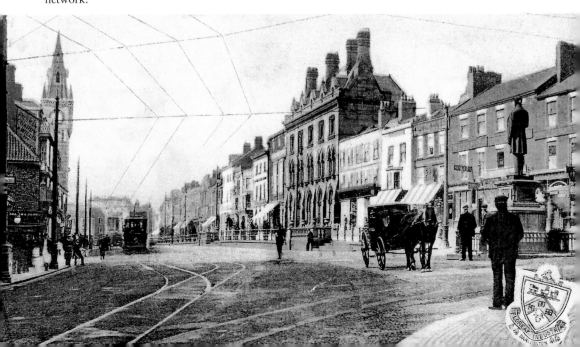

Stone came from quarries at Dunhouse, near Staindrop, and Gatherley Moor, near Melsonby, with red polished-granite columns 'judiciously dispersed' and topped with elaborately carved caps. The *Darlington and Stockton Times* praised the design, right up to the 'handsome perforated parapet' at the top and the 'elaborately wrought iron castings' along the ridge of the roof. Inside, it enthused over the 'spacious and commodious' banking hall, with its elliptical arched roof, beautifully inlaid floor of black-and-white marble, and 'its apparently interminable rows of French polished oak fittings and counterdesks [which] all bespeak unmistakeably of the imposing scale on which the bank has been designed'.

Upstairs was a luncheon room for the partners, entertaining rooms, bedrooms and kitchens, plus a very comfortable apartment, complete with a roof garden, for the manager and his family.

3c. Grange Road Baptist Chapel

When the chapel opened on 8 June 1871, *The Northern Echo* enthused:

> The handsome new chapel is much more imposing in appearance than the majority of Nonconformist places of worship, and is another indication of the growing feeling in favour of the introduction of high art and superior skill into buildings which formerly were intentionally divested of everything that could appeal to the outward senses.

Grange Road Baptist Chapel is now next to Sainsbury's supermarket and looks out onto a large roundabout.

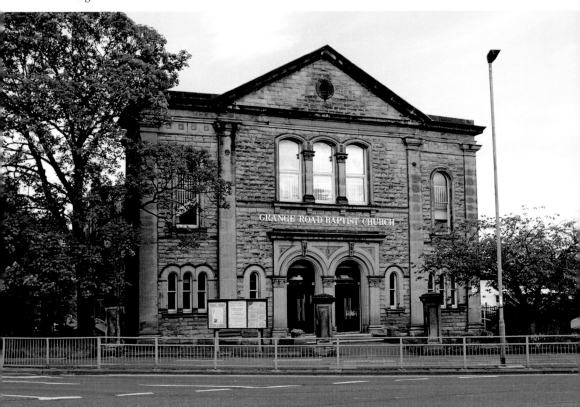

It was built of Forcett stone at a cost of £4,000 and seated 600 people. The superior skill behind it belonged to railway architect William Peachey, who worshipped at the chapel. In fact, Baptism had brought him to town as a twenty-eight-year-old in 1854, as he had followed the minister from his hometown of Cheltenham, who'd been sent to run Darlington's first Baptist chapel – in Archer Street. Peachey was a carpenter who recreated himself in the new town as an architect and within five years he was working with Henry Pease to create an upmarket railway seaside resort at Saltburn. He built the first houses in 1861, the railway station, and then the resort's magnificent centrepiece: the Zetland Hotel, with dramatic windows, splendid balconies, a sumptuous central tower, and the railway sweeping direct from London into its rear.

The Zetland was also gloriously overspent – it came to £33,000 above the £6,000 budget – and the Peases suspected Peachey was 'not quite straightforward'. They therefore shunted him into the architectural sidings for a decade, until allowing him to create Middlesbrough's station, which had a fantastic train shed that was destroyed by a bomb during the Second World War.

However, before the station was complete, on 5 January 1877, Peachey was summoned before the North Eastern Railway Board and resigned with immediate effect, without payment and with his draughtsmen dispensed with as well.

This spectacular fall from grace was hushed up, but it would appear that Peachey had again been taking backhanders from contractors. Aged fifty-one, he slunk off to Saltburn before he retired to Bromley-by-Bow, London, where he died in 1912, leaving in the north-east a grand clifftop hotel and a Baptist chapel 'of high art and superior skill'.

31. Teacher Training College

To the current generation, the building on Vane Terrace will forever be known as the 'arts centre' but it started as a women's teacher training college, set up by the British and Foreign Schools Society following the 1870 Education Act, which introduced state primary education. The college was funded by the Pease and Backhouse families, and residential places were sought after as they offered bright northern working-class teenage women a lucrative career – of the first thirty-eight pupils, twenty-seven passed their final exams and immediately became head teachers on £70 a year.

The college was designed by one of the north-east's leading ecclesiastical architects, James Pigott Pritchett (1830–1911). His H-shape had an educational wing of classrooms to the south, and a seventy-five-bedroom domestic wing to the north. It cost around £15,000, although even on opening day, 8 April 1876, they were still casting around for £7,000.

The young women were in the charge of a principal, who had to be female. The first was Miss R. Fish; the second was the fabulously named Miss Fanny Smallbones. Fanny caused the bewhiskered governing committee immense anguish in July 1879 by becoming engaged to her vice-principal, William Spafford. The committee sacked them both and asked them to reapply for their jobs. The principle of the principal being female was lost as they promoted Mr Spafford to the top job so he didn't have to take orders from his wife.

In 1889, Pritchett built a large practising school, named after Arthur Pease, at the rear where the trainee teachers got their first classroom experiences. Halls of residence were also built here – from Blanche Pease Hall in 1936 to Stanton Hall in 1965 – to increase pupil numbers.

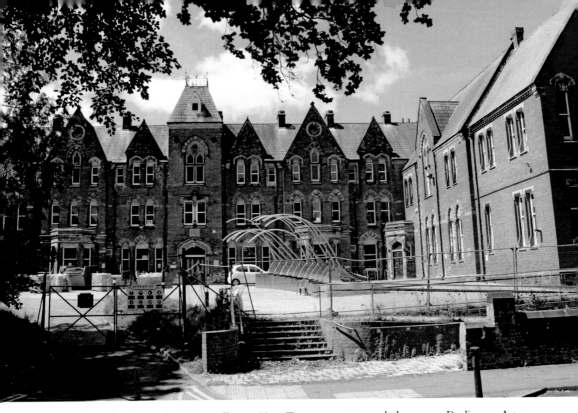

Above: The Teacher Training College in Vane Terrace, more recently known as Darlington Arts Centre, is now awaiting a new use.

Below: The Teacher Training College seen from across Stanhope Park on this Edwardian postcard.

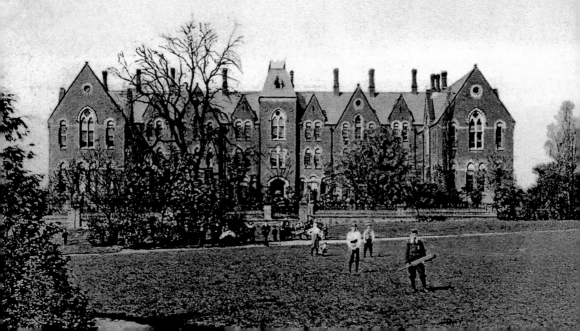

Darlington College

Men were admitted in 1966, but in 1968 Durham University opened a College of Education in old RAF buildings at Middleton St George. The two institutions amalgamated in summer 1978, causing the closure of Vane Terrace. Darlington Council controversially spent more than £400,000 converting it into the largest arts centre in the country, which US jazz singer Marion Montgomery formally opened on 10 April 1982. The centre required an annual £500,000 council subsidy, which evaporated at the beginning of the twenty-first-century's age of austerity and it closed, amid further controversy, on 14 July 2012.

32. Turkish Baths

Above a kitchen showroom at the top of Bondgate is a curious brick that has an oriental crescent moon and a four-armed star pressed into it, along with the legend: 'Estad July 1874'. The brick is a giveaway: this was the home of steamy Turkish baths.

The first Turkish bath opened in London in July 1860, making the concept of getting hot and sweaty in public very fashionable. In Darlington, James Wright, a 'Turkish baths keeper, hairdresser and umbrella manufacturer and repairer', moved into these purpose-built premises – with his brick – in 1877. He called the property Granville House – presumably after the Earl Granville, who was Foreign Secretary and joint leader of the Liberal Party during the 1870s – and he described it as a 'hydropathetic establishment'.

It was the Victorian equivalent of a health spa. Downstairs was a cold swimming pool, open to the public until 8 p.m. (solely for the use of ladies between 8 a.m. and 2 p.m. on a Friday),

Perhaps the most unlikely thing to find beneath a bathroom showroom floor is the remains of a late Victorian Turkish bath.

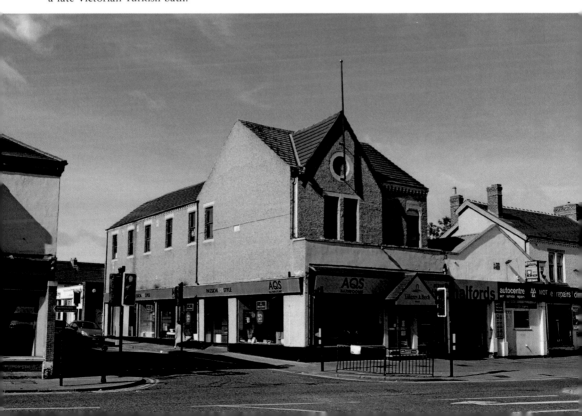

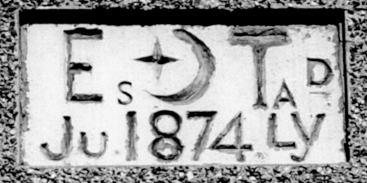

The giveaway brick on the Portland Place elevation of the former Turkish bath.

and upstairs were the saunas and steam baths. First-class residents paid £2 10s a week to stay, while third-class boarders paid £1 5s but had to use the rear Portland Place entrance. All prices included the healing hands of physician Dr Howison, and presumably Mr Wright, when he wasn't mending umbrellas, would use his hairdressing skills in an early beauty spa.

However, in 1888, Darlington Corporation roofed over the nearby Kendrew Street swimming baths and this pulled the plug on the Turkish Baths, which was wound up on 6 November 1890. The white-tiled baths still survive beneath the kitchen showroom's floorboards and, of course, the curious brick is still high up on the wall outside.

33. The Edward Pease Free Library

Edward Pease was the second son of Joseph Pease, whose statue is on High Row. Edward kept out of the family business, preferring mule breeding and fruit farming in Worcestershire, but he passionately believed in the benefits of self-education and lifelong learning. He was a prime mover in holding a referendum in Darlington to see if townspeople would increase the rate by a halfpenny to provide a free library, but, on 1 March 1870, they voted by 1,240 votes to 932 against (with 814 neutral) and so the books idea was shelved.

On 13 June 1880, Edward died in a five-star hotel in Switzerland, aged forty-six, leaving his fourteen-year-old daughter, Beatrice, an orphan. Much of his vast fortune was placed in trust for her, but £10,000 (worth more than £900,000 in today's values) was left to found a free library.

A second referendum was held on 14 July 1883, and returned a yes vote – by 3,420 to 599 no. The Peases donated the site on top of their old mill race and engaged their

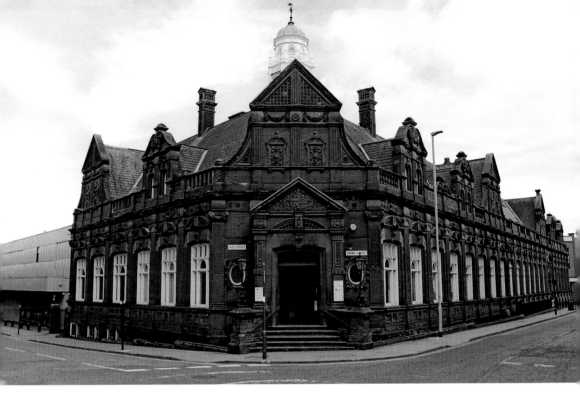

Above: The Edward Pease Free Library is a fine example of G. G. Hoskins' designs that came to typify Darlington in Victorian times.

Below: The Peases gave a piece of their old mill dam for the library to be built on but, as this Edwardian postcard shows, their mill still surrounded it.

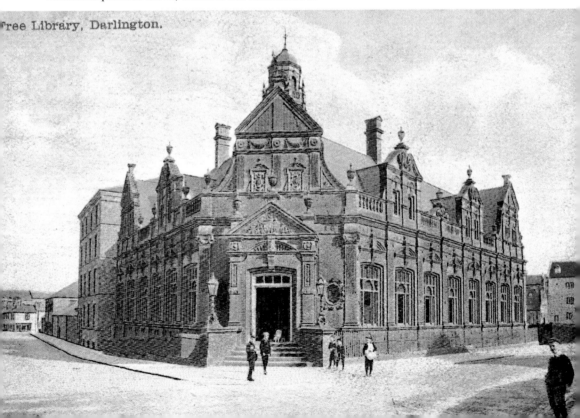

ree Library, Darlington.

The tympanum above the main entrance to
the library tells you all you need to know
about the building and its contents.

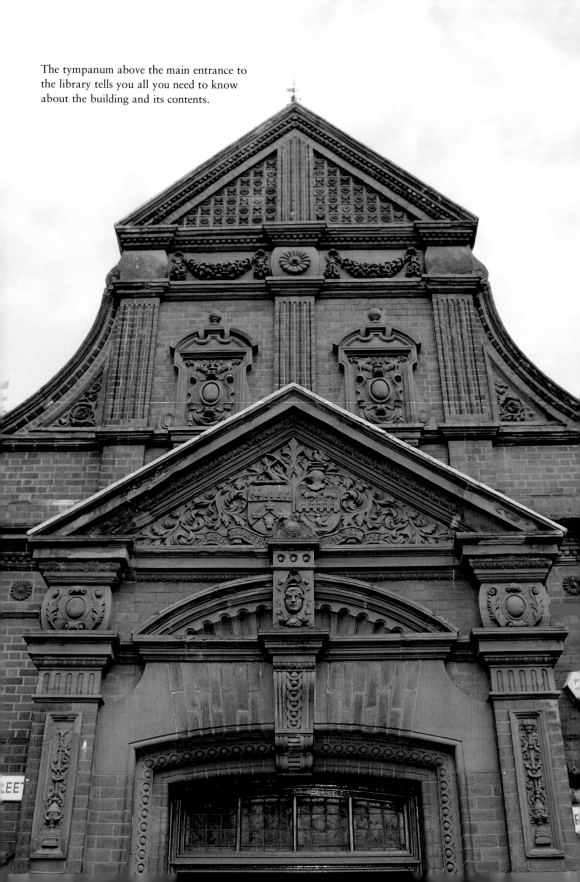

favourite architect, G. G. Hoskins, to create a Renaissance-style building. The tympanum over the entrance is particularly effective, combining the arms and mottos of the Peases and the borough with the head of Minerva (the goddess of learning) and a wise old owl reading a book.

The foundation stone, which can still be seen, was laid by Sir Joseph Whitwell Pease, on 4 June 1884, and the library was opened on 23 October 1885, with nineteen-year-old Beatrice the guest of honour. Such was the enthusiasm that after a huge crowd on a specially built platform had watched her turn the silver key, there was a lunch at the Trevelyan Hotel and then spill-over celebrations in the Mechanics Institute and the Friends Meeting House.

In 1899 the council acquired land beside the library, and initially planned a two-storey contemporary extension. Instead, on 27 March 1933, a £30,000 single-storey copy of Hoskins' design was opened. Unfortunately, in the early twenty-first century's age of austerity, despite a lengthy campaign to save the library, it was earmarked for closure in 2018.

34. Bank Top Station

On 28 September 1849, Queen Victoria's royal train stopped for fifteen minutes in the shed at Bank Top that was Darlington's first mainline station, leaving Her Majesty wondering why it was so shabby as Darlington was, she said, 'the place that gave birth to the railway station'.

The answer was that as the birthplace of the railways, Darlington's first station – North Road – was on the east–west line of 1825. The north–south main line of 1841 was a newcomer, and the cost-conscious railway directors were reluctant to go to the expense of a second station.

In the early 1860s, they replaced the Bank Top shed with a single-platform brick station, accessed by a new, wide street named Victoria Road.

Soon this station was too small and so, in early 1885, the North Eastern Railway's chief architect William Bell and engineer-in-chief, Thomas Harrison, began enlarging it. They demolished twenty houses, three pubs and a school, but kept the 1860s station's outer eastern wall – it is the section visible from the southbound platform that does not have oculi (rounded openings) in it.

They kept Victoria Road as the main entrance but made it far more impressive, utilising its natural elevation so that its imperious clock tower rises 80 feet over the town.

But Harrison liked island stations – stations that have their main waiting rooms and ticket offices on a central island with the up and down tracks flowing on either side. To allow passengers to go under the tracks to reach the island, shafts were dug for hydraulic lifts at the Victoria Road entrance, but the NER directors realised they would have to employ expensive lift operators round-the-clock.

And station general manager Henry Tennant argued passengers would find it more convenient to use the Parkgate goods entrance, which ran directly up onto the central island. So the lifts were scrapped, leaving the £100,000 station with a back-to-front feel.

On 2 July 1887, *The Northern Echo* reported: 'The new station at Bank Top, Darlington, was yesterday opened for traffic without any formal ceremony.'

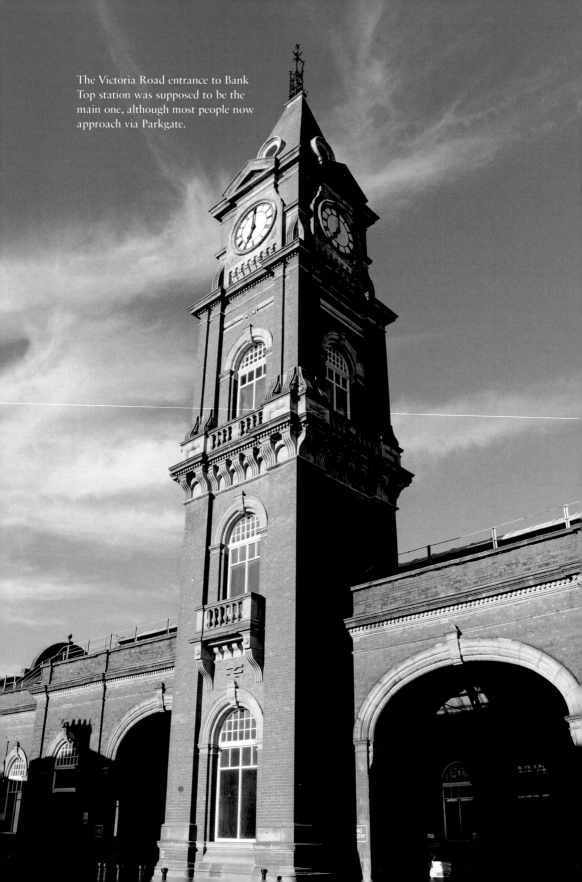

The Victoria Road entrance to Bank
Top station was supposed to be the
main one, although most people now
approach via Parkgate.

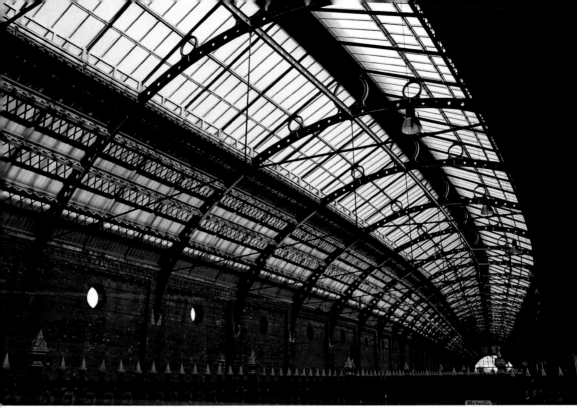

Above: The southbound platform in Bank Top station.

Below: An Edwardian postcard looking up Victoria Road to Bank Top station.

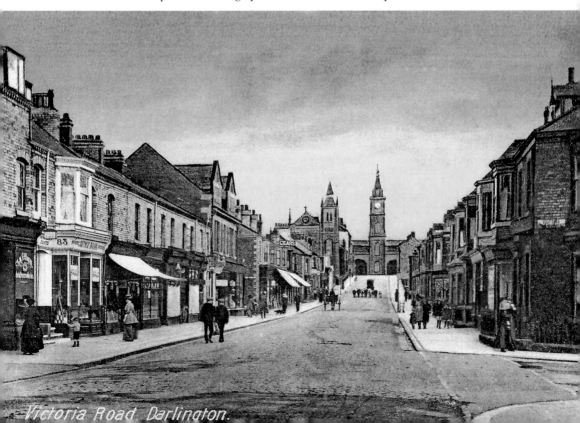

Victoria Road, Darlington.

35. King's Head Hotel

The King's Head is first mentioned in a sale notice of 1661, the year after Charles II was restored to the throne following his father's beheading in 1649. The hotel came into its own in the eighteenth-century coaching era, when it took three days to travel from London to Newcastle via Darlington, 'provided no material accident happens', and the trade enabled ostlers, stablemen, drivers and blacksmiths to work in the hotel yard, where eighty valuable horses were stabled.

But the advent of the railway – on 12 May 1821, when the first shareholders' meeting of the Stockton & Darlington Railway was held at the hotel – killed off the coaches, with the last leaving for London in October 1852.

In 1890, R. Fenwick & Co., brewers of Sunderland, bought it for £7,000 and tore it down. In its place, architect G. G. Hoskins – who also designed the library, the sixth form college, the technical college, Middlesbrough Town Hall, and many more – created what was described as 'a temple of luxury', which opened on 1 June 1893.

The main entrance, with an awning stretched over the Prebend Row pavement, was awe-inspiring, as the visitor entered a large panelled, mirrored vestibule with a marble mosaic floor. Having checked in at reception, he could choose to visit the grill room, buffet, smoke room, or bar.

'Even the general lavatory on this floor is a marvel of complete fitting, being fitted up with solid royal rouge marble, the walls lined with glazed tiles, and fitted with massive mirrors, and the whole equipment being in the perfection of sanitary work,' said the *Echo*.

In 1965–67, part of the Priestgate Co-op was rebuilt as an unlovely main entrance, and Prebend Row was converted into shops, losing Hoskins' great architectural drama.

The hotel itself was nearly lost in the town's biggest fire for a generation on 12 August 2008, yet when it reopened in 2012 as the Mercure, it had been so well restored that even Hoskins himself would have struggled to tell how badly his masterpiece had been ravaged.

The King's Head Hotel, restored after its 2008 fire and now called the Darlington Mercure, is probably G. G. Hoskins' finest building.

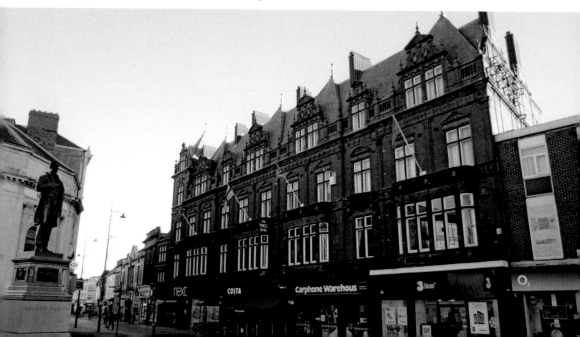

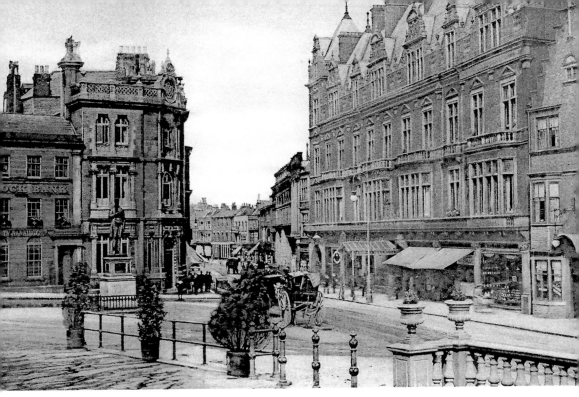

Edwardian postcard view of the King's Head Hotel, which was the town's premiere meeting place and coaching inn.

36. Darlington Quoits Club

On the front of a low, unnoteworthy brick building in a back lane behind Darlington town centre is an anonymous red wooden door with an ordinary round metal doorknob. Most people in Raby Terrace, at the rear of Skinnergate, are searching for a parking space and don't notice an enigmatic polished plaque in the centre of the door with a 'C' inside a 'Q'. Nor do they notice the giveaway inscription around the doorknob: 'Darlington Quoit Club 1846'.

Inside is the surprise inner sanctum of what is believed to be the oldest quoits club in the world. It was founded in August 1846 in the Dun Cow Inn in Post House Wynd, and the players threw their quoits wherever they could find a ground – they were evicted from Polam Hall by mansion owner Robert Thompson because of 'the disgraceful proceedings on the occasion of the match against Richmond'. The club's minute notes: 'Richmond players to blame'.

By around 1880 the club had established a 'refreshment hut' in Raby Terrace, near its new ground behind Skinnergate. In 1896, the club bought the property for £100, and the club president George Marshall, who was also a builder, started to construct a clubhouse. Mr Marshall, who is one of sixteen members of the club to have been mayor, opened the clubhouse, complete with ten earthenware spittoons, in 1898. It housed a bar and games room, and the minutes record that someone called 'woman' was employed to do the cleaning. In the yard behind were six ends for the playing of quoits. They still exist, although the club celebrated its 170th anniversary in 2016 by admitting women as full members for the first time.

Darlington Quoits Club is probably the oldest quoits club in the country, and yet it is tucked away behind an enormous door in Raby Terrace.

37. The Darlington Hippodrome

The New Hippodrome and Palace Theatre of Varieties opened on 2 September 1907, designed by George F. Ward of Birmingham, who was responsible for around fifty theatres across the north of England. One theatre historian has described its two-tone exterior, topped by a 64-foot water tower, as being 'riotous and wonderfully busy – a solidified fairground of shapes and motifs which proudly advertise the building's function as a hippodrome/music hall'.

The ringmaster was the managing director, Signor Rino Pepi, an Italian quick-change artist, whose wife was the equally characterful Mary, Countess of Rossetti. After wowing London's West End in 1898, Pepi had gone into theatre management in 1902 in Barrow. The Darlington Hippodrome was his fourth theatre, and he added others in Middlesbrough, Bishop Auckland and Shildon.

At 2.30 p.m. on 17 November 1927, Anna Pavlova, the biggest star on the planet, danced on his stage. Her booking was his greatest moment as an impresario, but, sadly, he died a few hours later, having missed the performance.

Without the charismatic Pepi, the theatre struggled against the cinemas and it fell dark on 16 June 1956. But Darlington Operatic Society (DOS) shooed out the pigeons, scrubbed down the chairs and opened triumphantly with White Horse Inn on 26 February 1958, in what they called the 'Civic Theatre' – the council had controversially put a farthing on the rates for repairs. When the lease ended in 1961, the council's valuation of the semi-derelict

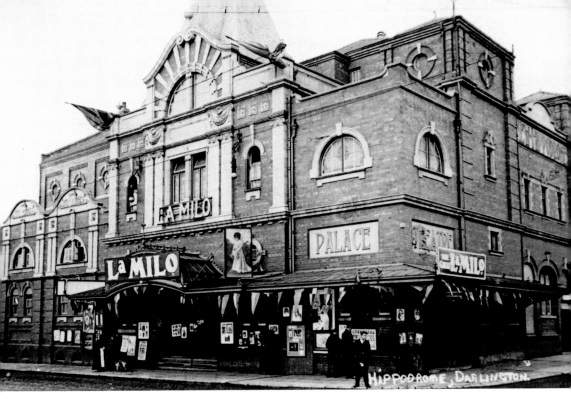

The Hippodrome and Palace Theatre of Varieties dressed up in 1911 for the arrival of La Milo, an infamous Australian actress who scandalised provincial backwaters like Darlington with her display of unmoving nudity.

hulk was a long way short of the owners'. To bridge the gap, on 4 November DOS heroically bought the theatre for £8,000 and sold it an hour later to the council for £5,500.

In the early 1970s, the council repaid the society's faith by appointing Peter Tod as director, and by the 1980s the Civic had the highest seat-occupancy rate of any provincial theatre in the country.

Reputedly one of the most haunted buildings in the north-east, the Civic narrowly survived the early twenty-first-century council cutbacks and a £12-million refurbishment (assisted by Heritage Lottery money) is due to be complete for panto 2017 with the name 'Hippodrome' going back above the doors.

38. Baydale Beck Inn

The Baydale Beck, the last property on the western edge of town, is Darlington's oldest inn sign. 'Baydalebeck hostelry is built of cobble stones of very small size, and has been an inn for time immemorial,' wrote William Longstaffe in 1854, 'but gained a bad name from its thievish frequenters … [that] … in its palmy days, none durst go near aft nightfall'.

It was a wayside watering hole on the boundary between the parishes of Darlington and Coniscliffe, lonely and lawless, the haunt of highwaymen. A celebrated clatch of thieves known as Catton's Gang used a five-doored room in the inn, which allowed them easy escape, as their headquarters. This, though, didn't prevent the gang's leader, 'Sir William Browne', from being regularly arrested. He was transported, but returned and was

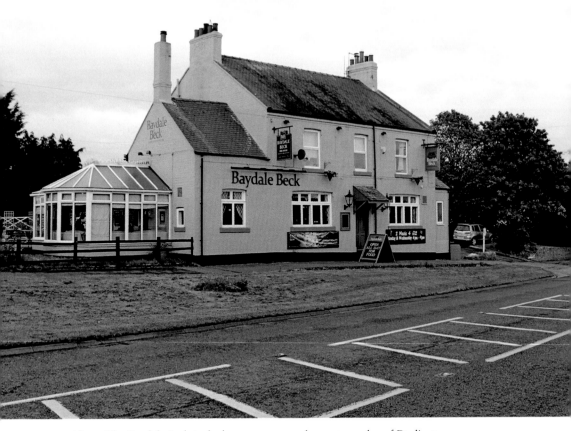

Above: The Baydale Beck is the last property on the western edge of Darlington.

Below: The Baydale Beck as it looked when it was the haunt of highwaymen, before it was rebuilt in 1910.

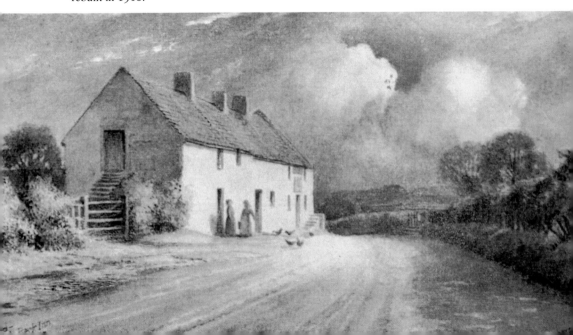

rearrested and on 2 August 1743, 'this desperate king of modern mosstroopers received sentence of death', says Longstaffe. He was hanged six days later as plain William Brown at Westgate in Newcastle but his ghost returned to his old haunts at Baydale.

The pub cleaned up its act. 'At present, it is a very favourite resort of the sprigs of Darlington, who rejoice in the capital oatcake and whiskey prepared by the worthy landlady, Mrs Naisbett,' said Longstaffe.

By the start of the twentieth century, the ancient inn butted onto the increasingly busy road. In 1910, its owner, Thomas Clayhill, solicitor and brewer, agreed to rebuild it slightly to the west, enabling the A67 to Barnard Castle to be widened.

Just before demolition, a photographer from *The Northern Echo* was allowed a last look. 'An air of legend and romance hangs round the walls of the old inn,' he wrote. He took pictures of an old iron bedstead in an attic room on which the highwayman was supposed to have slept, and he marked his negatives with an 'X' to show the secret doorway through which the mosstrooper was said to have eluded the constables.

All that has gone, but the stories live on, as does the pub's name. But what became of the ghost of Sir William Browne?

39. Stooperdale

Stooperdale is such a grand office building that, when it was built before the First World War, it was called Darlington's own Buckingham Palace, which is an appropriate nickname because it was built for a local railway nobleman, Sir Vincent Litchfield Raven, the NER's chief mechanical engineer from 1910–22.

The Stooperdale railway offices are so grand that they have been compared to Buckingham Palace.

'Everything that careful expenditure, architectural skill and good taste could do was done in its construction, and it remains a monument to the princely status of the North Eastern Railway,' said a railway historian in 1954.

No one has satisfactorily explained the name 'Stooperdale', but it was the name of an eighteenth-century farmhouse that found itself alongside the nineteenth century Stockton & Darlington Railway and its associated industries. After the North Eastern Railway erected a boiler shop and paint shop on its fields to augment the rapidly expanding North Road workshops, architect William Bell was called in to design Italianate offices fit for a railway prince that were approached by a crescent-shaped carriageway, with handsome gates and a dramatic portico. Under its cover, Mr Raven would arrive in his chauffeur-driven motor car from his home of Grantly, half-a-mile away on Carmel Road, every morning to take charge of everything that moved on the railway: 2,000 locomotives, 4,600 coaches, 11,200 wagons, plus lifts, lorries, cranes, hoists and tugboats, and not forgetting the 2,250 workers in North Road alone.

In 1917, Raven was knighted by Lloyd George and called into the government to help the war effort. His railway department transferred to York, and Stooperdale – barely a decade old – lost its prominence. Accountants arrived – many from Peterborough in the 1950s – and gradually pensions predominated. In 2002, Stooperdale was sold for £1,035,000 to its privatised occupants, Railways Pensions Management Ltd, which looks after around 500,000 pensions in its stately home.

40. The Majestic cinema

On Boxing Day 1932, the Majestic, Darlington's sixth purpose-built cinema, was opened on Bondgate by the deputy mayor Councillor Richard Luck and Charles Peat MP, who had been enticed away from their leftover turkey. The main attraction was *The Maid of the Mountains*, 'the greatest musical romance of all time'. 'In the three public performances which followed,' said the *Darlington and Stockton Times*, 'about 4,500 people paid for admission and high praise has been heard on all sides at the luxuriousness and comfort of the building, its excellent acoustics and especially at the massive organ which created a wonderful impression.' Darlington was already awash with cinemas. There was the Empire in Quebec Street (1911), the Arcade and the Court in Skinnergate (both 1912), the Scala in Eldon Street (1912), plus the Alhambra on Northgate (1913). There were also films being shown at the Central Palace in Central Hall, the Hippodrome in Parkgate, and the Astoria in Northgate.

But such was the enormity of Darlington's appetite for the silver screen, and despite the Great Depression, a consortium of local businessmen demolished a terrace of once grand Queen Anne houses and spent £30,000 creating the Majestic. Its star feature was its Compton organ, 'exactly similar' to one being installed in the BBC's Broadcasting House, said the *Darlington and Stockton Times*. It featured in around sixty live BBC wireless broadcasts, played by its resident organist, Harry Millen.

At the start of the Second World War, Darlington had eight purpose-built venues plus another four or five converted venues – it had more cinema seats per head of population than any other town in the country.

The Majestic, which seated 1,600 people, was a theatre-de-luxe and was probably the crème de la crème. In 1943, it was sold to the Rank chain for £92,500 and renamed the Odeon.

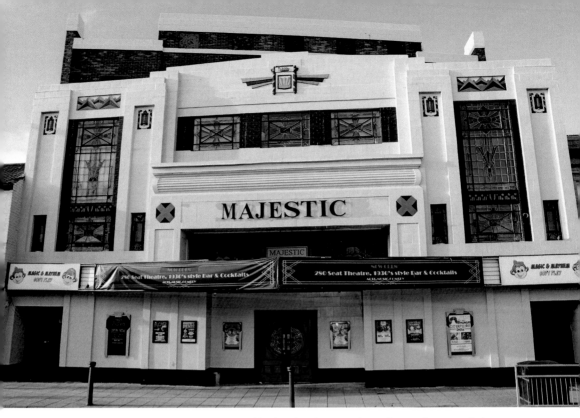

Above: The Majestic in Bondgate, designed by local architect Joshua Clayton, has recently been restored to its 1930s glory.

Below: The Majestic on Bondgate on a 1940s postcard.

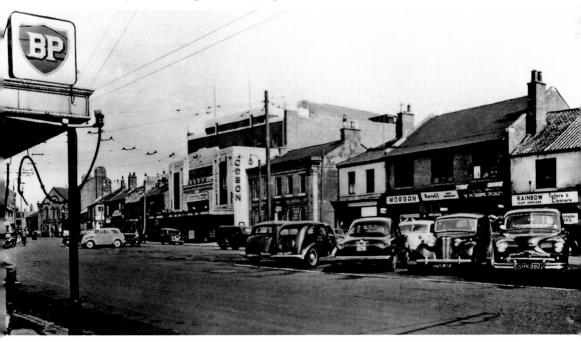

But the age of the silver screen was fading. The organ was sold in 1968 to an enthusiast in Manchester and in 1981 the Odeon closed. It reopened in 1986 as a snooker hall, which lasted until November 2012. The building was then auctioned for £146,000 to property developers, who have faithfully restored it as an entertainment venue – it is majestic once more.

41. Darlington Memorial Hospital

In early 1919, the townspeople were presented with three options by the War Memorial Committee as to how they might remember the fallen of the First World War. They could build a garden suburb in which the widows could live rent free, a town hall with a memorial wing, or a hugely ambitious hospital.

The hospital was narrowly chosen and workers began donating 3*d* a week from their pay packets. Before the summer was out, assisted by grants from the Red Cross, the Elms, a 17-acre estate on Hollyhurst Road, was purchased for £30,000, and an X-ray machine had been promised in memory of a soldier whose name was never released.

Interest then faded until, in 1924, the National Union of Railwaymen started a week-long railwaymen's carnival, which became a bi-annual fundraiser. In 1926, the Rotary Club adopted the children's ward, with its members building and then raffling a house in Haughton.

The hospital's foundation stone was laid in June 1926, and on 11 November 1928 the memorial obelisk was unveiled. On 9 November 1931, the Rotarians were nearing their £12,000 target for the children's ward and so, according to the *Northern Despatch*'s headline, 'Boy Cripple Lays Foundation Stone at Darlington'. The lad was twelve-year-old Raymond Featham of Park Street, whose father had been a prisoner of war.

The formal opening of Darlington Memorial Hospital was on 5 May 1933 by Prince George, the king's youngest son, who had a playboy reputation. It was both a

The original wing of the Darlington Memorial Hospital – with the war memorial in shade in front.

The memorial is now a very modern hospital, sprawling across its site off Hollyhurst Road.

commemoration and a celebration, with the prince unlocking the door of the Bradford Memorial Porch, built in memory of Roland and George Bradford, the only brothers in the war to have won the Victoria Cross and who had grown up in nearby Milbank Road. He went through the porch into the memorial hall, its walls lined with the names of 700 men killed in conflict. He said: 'I am sure that this hospital is a most fitting memorial to those who fell in the war, and its usefulness is, without doubt, far greater than a formal memorial of the usual type.'

Of that original hospital, only the memorial hall survives. The most major modernisation concluded in May 1980 when the Duchess of Kent opened the main wing.

42. Lingfield Point

After the Second World War the wool firm of Patons & Baldwins relocated from its several west Yorkshire factories, which climbed several storeys up the valleys to one single-level factory built on 140 acres of flat farmland on the eastern edge of Darlington, beside the Stockton & Darlington Railway.

It was the world's largest wool factory, with 40 acres of buildings built from 14,000,000 bricks, 13,500 tons of steel, 20,000 gallons of paint and 12.5 acres of glass in the roofs. Beneath the glass was 1.7 million square feet of floor space in which all of the British-built machinery was powered by steam generated in the powerhouse.

Fleeces came from all over the world and were pushed into the factory by a fireless steam locomotive for washing – the resultant gloop was sold as lanolin to the cosmetic industry

Lingfield Point was a post-war model factory built beside the Stockton & Darlington Railway trackbed.

Inset: Lingfield House, the main office block, is one of the finest examples of brutalist architecture in the north-east.

for ladies' face powder. The fleeces were then loaded onto a 2.5-mile long conveyor belt that travelled at 3 mph through the various processes to produce knitting wool.

At its peak in the early 1950s, the factory employed 3,500 people – 75 per cent of them women. Thirty per cent of all Darlington female school leavers started their working careers at P&B, and a fleet of fifty buses brought in more women from miles around.

There were two canteens that could seat 2,000, twelve tennis courts, two bowling greens, football and cricket pitches and 25 acres of fields and gardens. At night, the larger dining room was transformed into the Beehive ballroom, Darlington's hottest dancehall in the 1950s.

Cheap overseas competition and the advent of funkier materials like nylon forced P&B to slim drastically, and on 17 April 1980 production ceased, with 350 employees left to concentrate on logistics and warehousing.

Rothmans arrived in the biggest inward investment in the north-east in the 1970s, employing 1,000 people who produced 100 billion cigarettes in a decade. When it

left in 2004, the wonder factory and its spectacular brutalist office, with its sweeping double staircase, was converted into a business park that still provides work for more than 2,500 people.

43. Chrysler Cummins Factory

There are thirty-one Grade II*-listed buildings in the borough of Darlington – they are among the most important 8 per cent of buildings in the country. Only the Chrysler Cummins plant on Yarm Road is a twentieth-century construction, where even the kerbstones around the rectangular feature pool and the security fence are specifically listed.

The technical entry in the listed buildings schedule gives a hint as to what lies behind its elegant smoked-glass windows: 'First use in a British building of Cor-ten steel, and first large scale use in Britain of neoprene gaskets in a building.' How exciting!

Chrysler Cummins, the American diesel engine manufacturer, was attracted to Darlington in the early 1960s in a bid to make up for the catastrophic collapse of the railway industry – 7,000 jobs went in the decade either side of the Beeching Axe.

The Yarm Road factory, which employs 2,000 people, was the first UK commission for Connecticut architects Kevin Roche and John Dinkeloo, who have since designed industrial and commercial buildings across the US, Europe and Asia – even the Central Park Zoo in New York is theirs.

It is a traditional American plant, designed for the maximum flexibility of its interior space. Its key features are its steel frame and its glass walls. The frame is deliberately

The Cummins factory on Yarm Road is a Grade II-listed groundbreaking building.

exposed to emphasise the building's industrial nature and, because, like the *Angel of the North*, is made from Cor-ten steel (short for 'corrosion resistant and tensile strength'), it has a rusty appearance. The dusky windows are held in place not by putty but by strips of a synthetic rubber called neoprene, which creates a gasket-like seal. The idea was borrowed, appropriately, from the car industry, and led one critic to say: 'Perhaps for the first time in England, the ancient dream of a glass wall without draughts has been realised.'

What the Queen made of it when she formally opened it on 20 October 1967 – it had been producing engines for a year by that time – is, of course, unrecorded, but she must have been impressed by this groundbreaking example of 1960s industrial architecture.

44. Town Hall

Almost as soon as it was completed in 1864, Alfred Waterhouse's town hall and covered market complex was not large enough for growing municipal needs and people were planning to replace it. During the 1960s and early 1970s various hideous proposals – the Shepherd Scheme and the Tornbohm Plan – suggested populating the town centre with concrete-and-glass boxes, the first of which was to be a £1.1-million town hall. It was described as a collection of 'clean and uncomplicated' modules in a T-shape with plenty of potential for extension.

It was designed by borough architect Eric Tornbohm and his assistant, William T. Boyd, with further assistance from Williamson, Faulkner Brown & Partners, the Newcastle architects who were well regarded for their libraries, sports complexes (including a stand at St James's Park) and the Tyne and Wear metro.

The council chamber of the Town Hall.

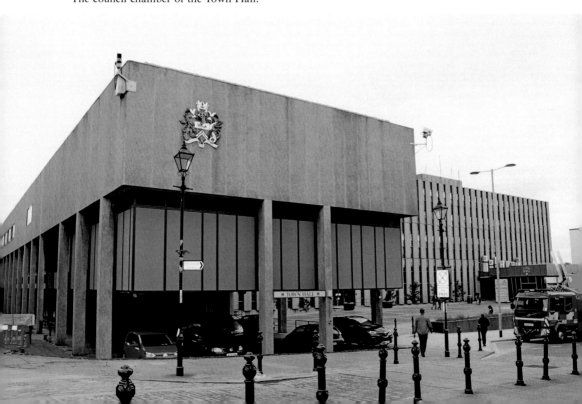

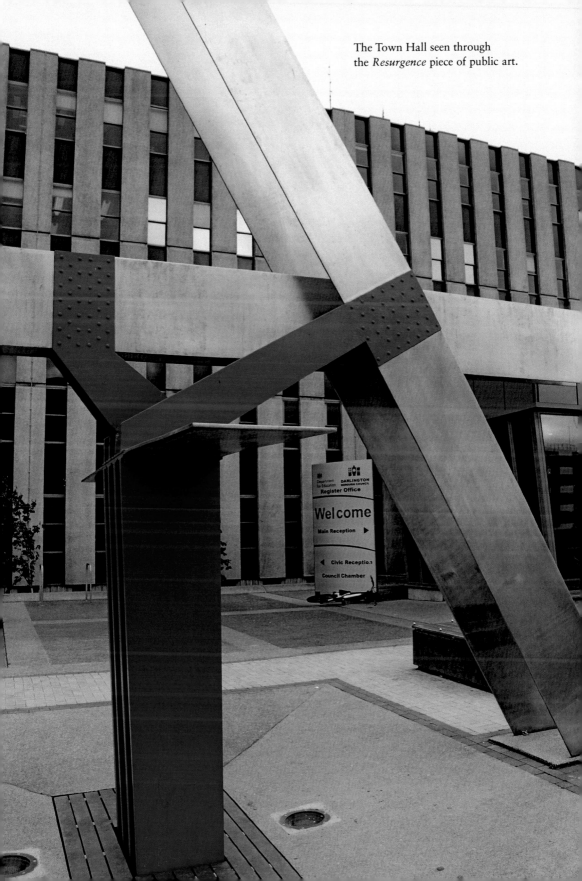

The Town Hall seen through the *Resurgence* piece of public art.

Housing minister Anthony Greenwood laid the foundation stone on 30 November 1967, and 500 reinforced-concrete piles were sunk without physically disturbing St Cuthbert's Church next door. Indeed, the architects tried not to disturb the ancient church visually as well, with their vertical reconstructed granite panels inspired by the upward motion of the steeple, although the Pevsner guide to County Durham says that the town hall was 'thoughtfully designed but not quite happy in its relationship to the church'.

Princess Anne, the Queen's only daughter, seemed bemused when, on 27 May 1970, she formally opened the complex and unveiled the zinc and stainless steel sculpture *Resurgence*, which graces the plaza outside. *Resurgence*, by Cheltenham architect John Hoskin, symbolises Darlington's escape from industrial decline, but, like the rest of the town hall, is a product of its time.

Perhaps it is not helped by its time coming abruptly to an end. The Tornbolm Plan collapsed in 1972 and so the town hall is without any neighbouring concrete-and-glass boxes. It looks rather lonely and disconnected – Feethams was supposed to be pedestrianised and raised so that the plaza joined the Market Place.

However, the council chamber has a feeling of subdued 1970s elegance to it. Deliberately deprived of daylight so that its vertical ribs of elm could be gently lit upwards, it is now a popular wedding venue.

45. Morrisons North Road

At the end of the 1970s, supermarket firm Morrisons was sniffing around a 27-acre site in North Road with a derelict factory on it. The factory had been closed since 1966, and despite being marketed as having 'unlimited opportunities for new and expanding industries or for exploitation as an industrial estate', there had been no takers.

Morrisons proposed Darlington's first out-of-town supermarket for the site, and Environment Secretary Peter Shore was consulted. He said there was no 'shopping need' for such a thing, and North Road traders got up a petition, but it went ahead anyway, and opened in 1980.

Councillors were dismayed by the supermarket's blank brick walls – but at least a large Potts clock was screwed precisely where it had hung since 1894, over the arched entrance to what had been Darlington's largest employer: the North Road Shops.

The workshops had opened on 1 January 1863 and had encouraged a sprawl of terraces to house their hundreds of workers – at 5 a.m. a bell echoed across the streets, waking the men for their 6 a.m. start.

Every skill had its own workshop: wheel shop, millwrights' shop, coppersmiths' shop, brassmoulders' shop, boiler shop, flanging and tube-repairing shop, tinsmiths' shop, brass-finishing shop, plate bending and straightening shop, joiners' shop, patternmakers' shop. All the parts came together in the erecting shop, where the engine was built. There was even an artificial limb shop for railwaymen caught in accidents.

When the First World War broke out, North Road was producing a new engine every fortnight and employing 2,366 men. In 1929, in secret behind a large curtain to prevent spying, it built locomotive No. 10,000, the *Hush-Hush*, which was Sir Nigel Gresley's first revolutionary experiment in streamlining. North Road peaked in 1954, employing 4,000 men who built fifty locomotives a year and maintained the nationalised fleet of 1,724 engines.

Above: The blank walls of the Morrisons supermarket on North Road concerned councillors in 1980.

Below: The supermarket replaced the North Road shops, which once employed thousands of railwaymen. The wall clock hangs in the same position, only on a different building.

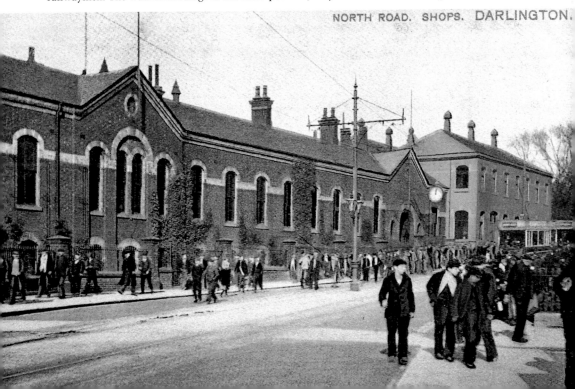

NORTH ROAD. SHOPS. DARLINGTON.

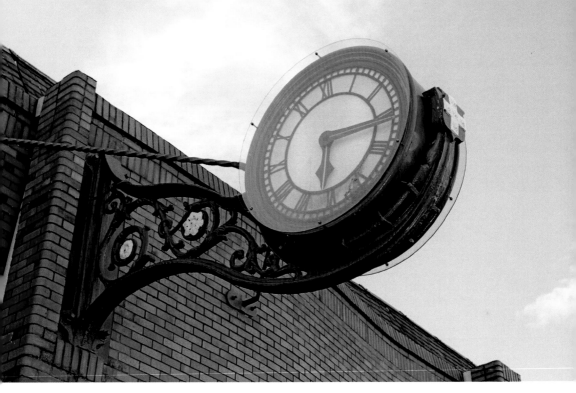

The Potts clock – made by a Leeds firm founded by a Darlingtonian – hangs on the supermarket wall where the entrance to the workshops was once.

The network was being dieselised, and in October 1957 North Road produced the last of its 2,269 steam locos, BR No. 84029. Then, on 1 April 1966, despite a spirited SOS ('Save Our Shops') campaign, it closed. Darlington had ceased to be a railway town, although soon you could shop to your heart's content.

46. Dolphin Centre

Arising from the ashes of Darlington Council's rejected 1960s plans to cover the town centre with a concrete-and-glass civic centre was the idea of a leisure centre and swimming pool. It was talked about from 1967 and got the go-ahead in 1977.

It was to cover a mass of ageing outbuildings and yards from Houndgate through to the Market Place, including the Dolphin Inn, which was nicknamed 'the crooked fish' because of its badly drawn inn sign. There was debate about whether its neighbour, Central Hall, which had opened on 2 June 1847, should be demolished, but borough architect Gabriel Lowes imaginatively incorporated it into the new complex.

Construction was delayed by a steel strike and blighted by inflation: what had started as a £2.5-million project became a £23-million leisure centre when it was formally opened – a year late – on 2 November 1982 by athlete Sir Roger Bannister, the first four-minute miler.

Weighed down by the overspend, the centre immediately ran into problems. Its revolutionary heating system, which had won a £70,000 EC grant, was so efficient that

The Dolphin Centre was plagued with problems after its opening in 1982.

it sent the water temperature in the swimming pools soaring to 89 degrees Fahrenheit. Then, within weeks of the opening, the main pool sprung a leak, which cost £10,500 to fix, and within a year investigations suggested faulty mortar had been used, which led to a £1 million repair bill.

All the repointing was complete by the centre's tenth anniversary, and it began to win over the townspeople. By its twentieth birthday it celebrated welcoming its 28-millionth visitor; just after its 25th anniversary a gym refit prompted Alan Milburn MP to claim that it had the facilities of a 'five-star hotel'. To commemorate its 30th anniversary, the face on the town clock turned blue. In 2017, plans were hurriedly drawn up to squeeze library services into it when the Crown Street library was earmarked for cost-saving closure.

47. The Cornmill Centre

Darlington was radically reshaped by the Cornmill Shopping Centre at the end of the twentieth century. The 164,000-square-foot mall swept away 125 years of Co-op history, but managed to conceal much of itself behind the sixty-five old shopfronts that remained on Tubwell Row, Prebend Row, Priestgate and Northgate.

Developers Pengap began devising the scheme in 1982, and it started to leave the drawing board in April 1986 when Darlington Co-op, formed in the street in 1868, announced it was to close with the loss of 112 jobs. Once the Co-op's departments had supplied all Darlington's needs, even in 1899 introducing a line of dentist-designed artificial teeth. It had risen so high that its top floor contained a famous dancehall, and it had spread so wide that in the early 1960s it had burst out onto Tubwell Row with a pair of loudspeaker-like elevations that drowned out the 250-year-old Raby Hotel sandwiched between them.

But, in turn, the Cornmill swept away the Co-op in July 1988 – not even the Raby could withstand its bulldozers. The lead architect was Stephen Gray of the AAP Partnership, who drew inspiration from the surviving buildings, particularly G. G. Hoskins' two-tone terracotta and brick style. He was particularly proud of the Cornmill's central glass atrium. 'The geometry pleases me immensely,' he said. 'It's a mathematically pure piece of structure.' Uncharitable locals, though, likened the exterior to a 'Second World War concentration camp'.

The £60-million centre was opened on 27 August 1992 by the mayor, Councillor David Lyonette, and seventeen-year-old Richard Blair of Witton-le-Wear, who had won a competition to name the complex five years earlier – the Bishop of Durham's corn mill had been on the Skerne on the opposite side of Crown Street where a multistorey car park was later built.

The Cornmill Centre was Darlington's biggest construction project of the twentieth century, involving more than 350 men on site at its peak. It changed the face and character of the town centre like no other building.

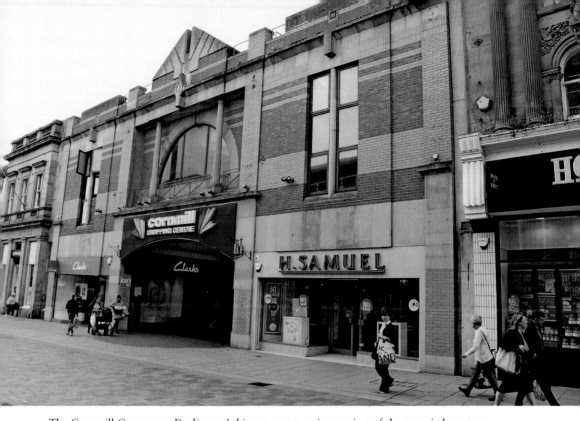

The Cornmill Centre was Darlington's biggest construction project of the twentieth century.

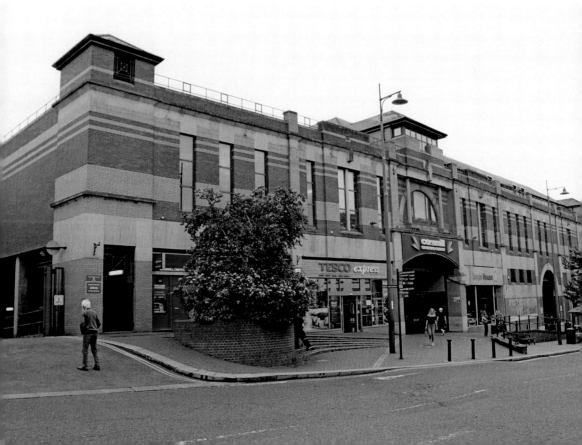

48. Darlington Arena

On 16 August 2003, Darlington FC's first match in its £20-million, 25,000-seater stadium ended in a 2-0 defeat to Kidderminster Harriers in front of a record crowd of 11,600. It was an omen of the troubled times ahead as, ultimately, the colossal stadium dragged the Quakers into oblivion.

The club was formed on 20 July 1883 and played at Feethams, the home of Darlington Cricket Club since 1866. The Skernesiders turned professional in 1908 and, despite a fabulous FA Cup run in 1910–11 in which it became the first non-league club to win at a First Division opponent, the debt-ridden club folded at the start of the First World War.

It was rescued by Darlington Forge Albion, a pub side managed by landlord J. B. Haw. Legendary manager Jack English took the Quakers into the new Football League Division Three (North) in 1921–22, and for the next eighty years they flirted with the nearly highs and the extremely lows of lower league football while attracting an average crowd of less than 3,000. Every stunning success, like the 4-1 victory over Chelsea in the FA Cup fourth round reply in 1957–58, or the double championship wins of the Brian Little years from 1989–91, was matched by defeats, relegations and – five times in the 1970s alone – pleas for re-election to the Football League.

Plus there were always debts. In 1999, the club was at least £5 million in red but safebreaker-turned-chipboard-king George Reynolds, worth an estimated £280 million, baled it out and built the Reynolds Arena, which is to the town what the wall is to China.

Within six months of the Kidderminster match, the club was in administration with debts of £1 million. Within eighteen months Mr Reynolds was in jail for tax evasion,

Below and opposite: The Darlington Arena, the former home of Darlington FC, is now the biggest rugby stadium outside Twickenham.

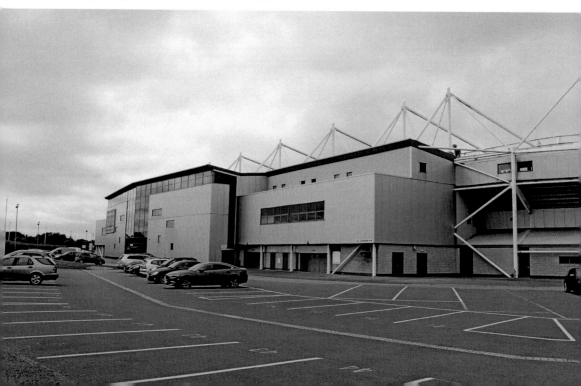

having poured in an estimated £32 million. In January 2012, the Quakers plunged into administration for the third time in a decade; this time the Football League relegated them four rungs down to the Northern League, and they were ejected from their own stadium.

Darlington FC reformed as a community-owned club to begin the long fight back, and Mowden Park Rugby Club took over the arena, making it the biggest rugby stadium in England outside Twickenham.

49. Darlington College

'Special and spectacular' was how Tony Blair, the Prime Minister and MP for Sedgefield, described the £35-million Darlington College, which he opened on 21 December 2006. Its large, airy glass-bowl entrance was certainly a contrast to the dark and austere £16,000 technical college on Northgate.

The technical college, designed by G. G. Hoskins, had been ceremonially begun when Alderman Arthur Pease cemented in place the foundation stone beside the pavement in 1896, only for the council to realise that the architect hadn't been told about its recent purchase of an 8-foot 9-inch strip of land at the rear of the site so that the college could be set back. Too late! The college rose in Hoskins' trademark two-tone terracotta, topped by two 6-foot 6-inch statues of female figures representing Art and Science.

It was opened on 8 October 1897 by the Duke of Devonshire, the Lord President of the Council of Education. It got a mixed reception. One critic dismissed it as 'Darlington's latest white elephant', but in 1898, 702 students enrolled – mainly males studying single subjects in their own time at their own expense – and in 1905 Sir Isambard Owen, the principal of Armstrong College, Newcastle, said it was 'a beautiful monument to the town' when he opened an extension.

By 1955 it had grown so that teaching was taking place in twenty-eight venues dotted all over town, so it was consolidated onto one site, the former Darlington Girls' High School in Cleveland Avenue. Now called the Darlington College of Further Education, it continued to expand until there was no room left there, and so it decamped to Central Park off Haughton Road.

Darlington College was described as 'special and spectacular' by Prime Minister Tony Blair when he opened it in 2006.

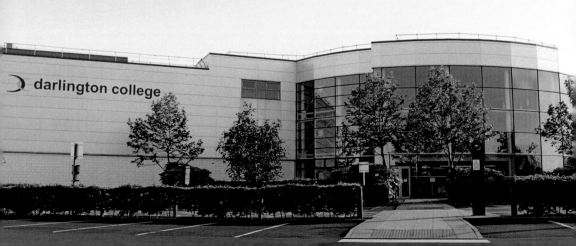

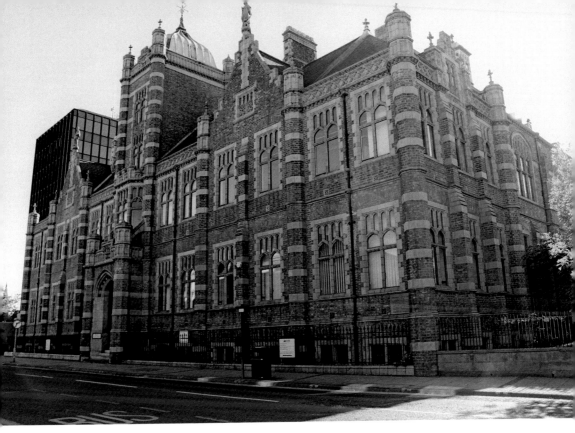

Above: The original technical college on Northgate was designed by G. G. Hoskins.

Below: An Edwardian postcard of the technical college on Northgate.

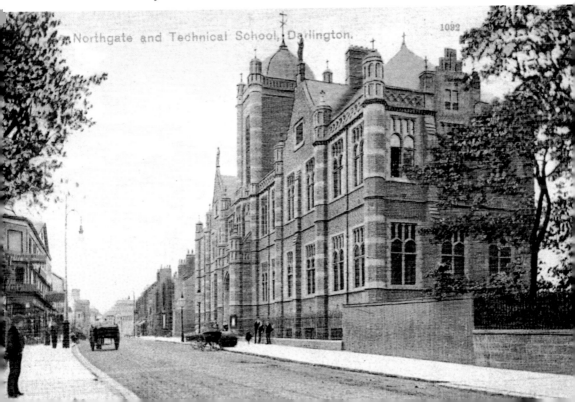

50. Bishopsgate House

On 19 March 2015, the £8.3-million Bishopsgate House was opened behind Darlington Town Hall on the western bank of the River Skerne by the Director General for the Department for Education, Andrew McCully, Jenny Chapman MP, and council leader Bill Dixon.

The opening marked the end of a three-year campaign to prevent the government from closing the education offices in Mowden Hall, which was no longer fit for purpose, and transferring the 430 civil servants to Newcastle.

Instead, their workstations were relocated to the strikingly twenty-first-century building, which contain 1,100 square metres of glass held up by 350 tonnes of Teesside steel. It completed the T-shaped footprint planned for the Town Hall in the 1960s and was slightly set back from the waterfront so that it did not distract from its twelfth-century neighbour, St Cuthbert's Church.

Its construction allowed archaeologists to delve beneath the tarmac of an old car park and discover what was left of one of the town's most important buildings, the Bishop's Palace, built by Bishop Hugh de Puiset in the late twelfth century – probably on the site of an older manor house and probably a few years before he commenced work on St Cuthbert's. Judging by the 250 pieces of Romanesque stonework found in the ground, it was well built and whitewashed.

Because he had so many palaces elsewhere, the Darlington one became his estate offices and a place where his guests could stay. For instance, in the mid-seventeenth century, when the Civil War was waging, the bishop's daughter, Lady Jarrett, was taking sanctuary there when she was murdered for her ruby ring. Her ghost – the most regularly spotted in town – is still said to haunt the area.

Bishopsgate House, beside the Skerne, was first imagined in the late 1960s.

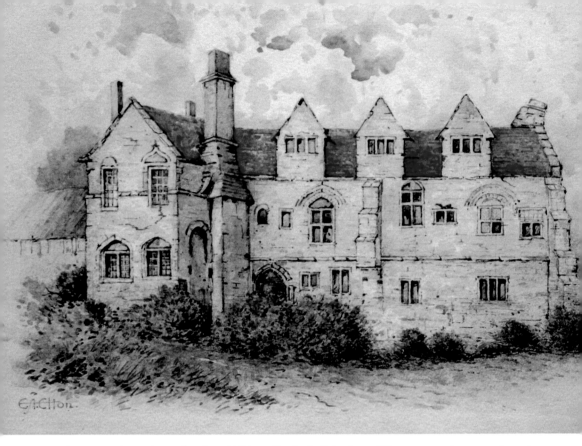

Bishopsgate House is on the site of Bishop Hugh de Puiset's twelfth-century palace, seen here in around 1813.

In 1703, Bishop Nathaniel Crew allowed the surplus palace to be converted into a workhouse, which was pulled down in 1870 by Richard Luck, shopkeeper and mayor, who had a frightening encounter with the ghost of Lady Jarrett. The bishop's connection to the site lives on in the education offices' name – and for all its orangey modernity, perhaps the ghost of Lady Jarrett haunts on too.

Bibliography

Chapman, Vera, *Rural Darlington: Farm, Mansion and Suburb* (Durham County Copuncil, 1975).

Cookson, Gillian (ed.), *The Victoria History of the County of Durham, Vol IV: Darlington* (Boydell & Brewster, 2005).

Crosby, J. H., *Ignatius Bonomi of Durham Architect* (City of Durham Trust, 1987).

Flynn, George, *The Book of Darlington* (Barracuda Books, 1987).

Friends of the Stockton & Darlington Railway: Self-Guided Walks (FS&DR, 2016).

Fawcett, Bill, *A History of North-Eastern Railway Architecture, Vols 1–2* (North-Eastern Railway Association, 2010–13).

Lloyd, Chris, 'Memories of Darlington Vols 1–3' (*The Northern Echo*, 1992–2001).

Lloyd, Chris, 'Of Fish and Actors: 100 Years of Darlington Civic Theatre' (*The Northern Echo*, 2007).

Lloyd, Chris, 'The Road to Rockliffe' (*The Northern Echo*, 2010).

Lloyd, Chris, *Darlington in 100 Dates* (The History Press, 2015).

Longstaffe, William, 'The History and Antiquities of Darlington' (*Darlington and Stockton Times*, 1854).

McDougall, C. A., *The Stockton & Darlington Railway 1821–63* (Durham County Council, 1975).

McNab, Charles, *At the House of Edward Pease* (Darlington Historical Society, 2011).

Mewburn, Francis, *The Larchfield Diaries* (Simkin, Marshall & Co., 1876).

Orde, Anne, *Religion, Business & Society in North-East England: The Pease Family of Darlington in the 19th Century* (North-East England History Institute, 2000).

Pease, Alfred Edward (ed.), *The Diaries of Edward Pease, The Father of the English Railways* (Cambridge University Press, 2013).

Pevsner, Nikolaus, *The Buildings of England: County Durham* (Penguin, 1953).

Pritchett, H. B., *The Church of St Cuthbert* (William Dresser, 1924).

Wedgewood, Maurice (ed.), *Parish of Holy Trinity* (Holy Trinity Church, 1989).

Website: Something Concrete and Modern.

Newspapers: *The Northern Echo, Darlington & Stockton Times,* and the *Evening Despatch.*